# AN UNREASONED ACT OF BEING

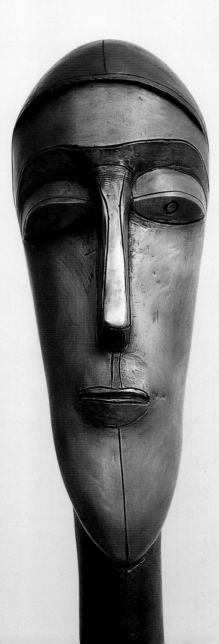

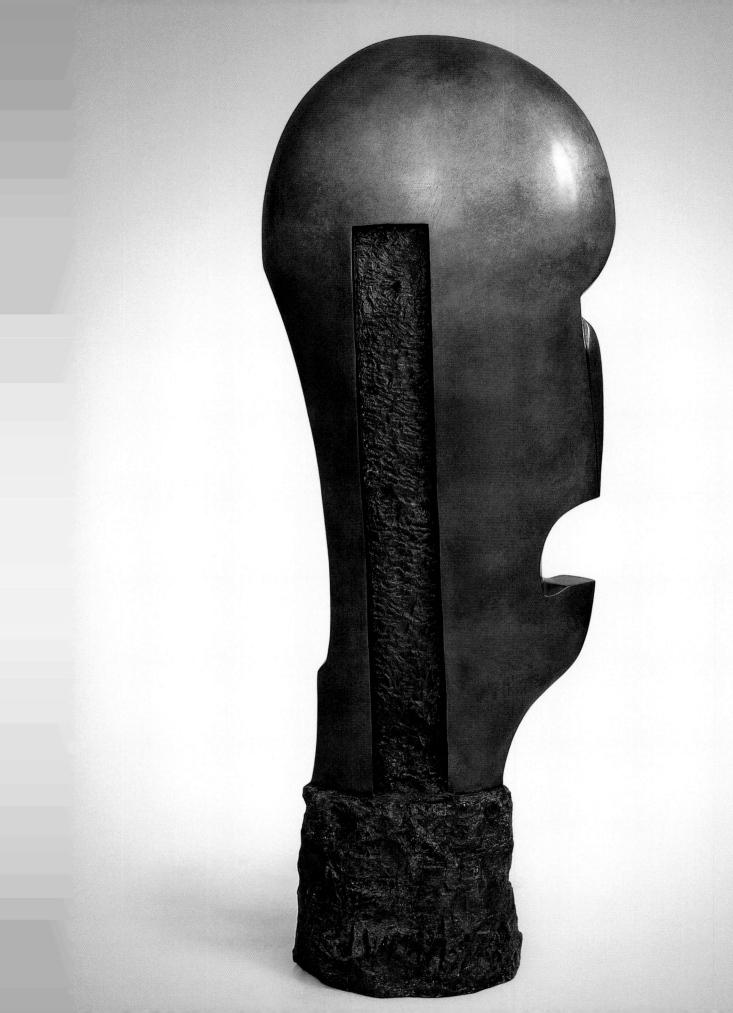

CONTEMPORARY INDIAN ARTISTS SERIES

# AN UNREASONED ACT OF BEING
## SCULPTURES BY HIMMAT SHAH

Gayatri Sinha

**Mapin Publishing** | **Lund Humphries**

Himmat Shah is an exceptional individual; even at the age of 75 he retains a kind of childlike innocence. A true artist, he is the only Indian sculptor to have gained worldwide recognition that only a handful of painters in India have managed to achieve. The art fraternity, too, holds his work in high esteem.

Intensely passionate about details and techniques, Himmat Shah has remained dedicated to the tools of his trade. Though he is seen primarily as a sculptor, his initial training as a painter cannot go unnoticed. He sometimes endeavours to integrate concepts from both forms, creating unique works. The resultant body of art, which establishes a world that holds together references from diverse elements, never fails to leave the viewer spellbound.

It has been our privilege to have known Himmat and to have worked with him. A selection of heads that feature in this publication focus on one aspect of Himmat's work. It presents a sampling of his brilliance, and it is hoped that future publications document the entire gamut of subjects he has touched upon in his long career.

Tanuj Berry & Saman Malik

March 2007

New Delhi

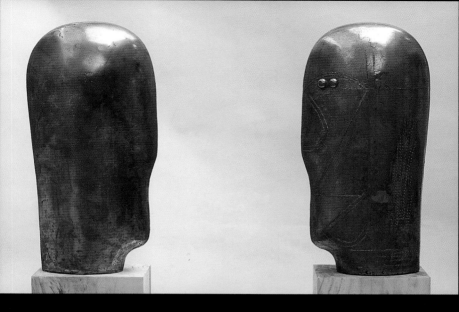

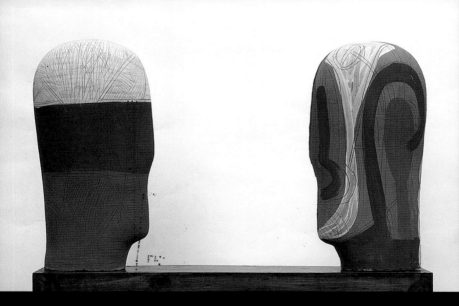

Lines to Himmat,

11th March 2007

It seems an age since we had neighbouring studios in Garhi. It was time well spent. Insights into each others work were not forced and came naturally over a long period of time. Inevitably, that time came to a stop though happily there were no ruptures in our long association.

It may seem strange, though it is really not so that Tanuj and Saman chose both you and me and extended the kind of professional and friendly help which seems so important in the times we are living in.

I was given an opportunity this morning to see your new work much of it executed in a workshop in London. I did not expect to see the great difference between what I had known and what stood before me. I had feared that, like so many others, you too might be swept away by fashionable winds. I was delighted to see that you have not forsaken your vision. Vision is a small word used indiscriminately now a days. At its

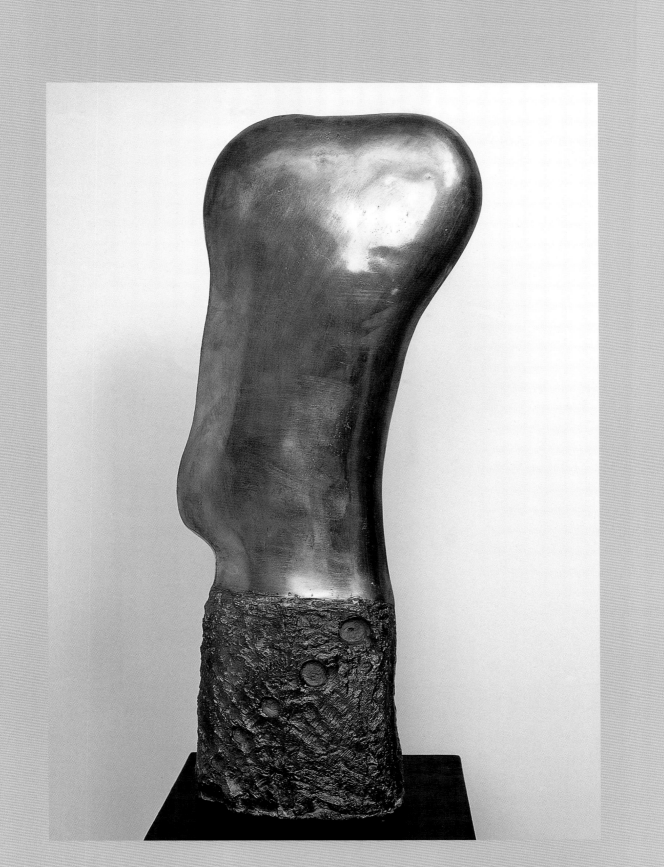

**Bronze, 35 x 13.5", Edition of 7** Following page: **See pages 86–87.**

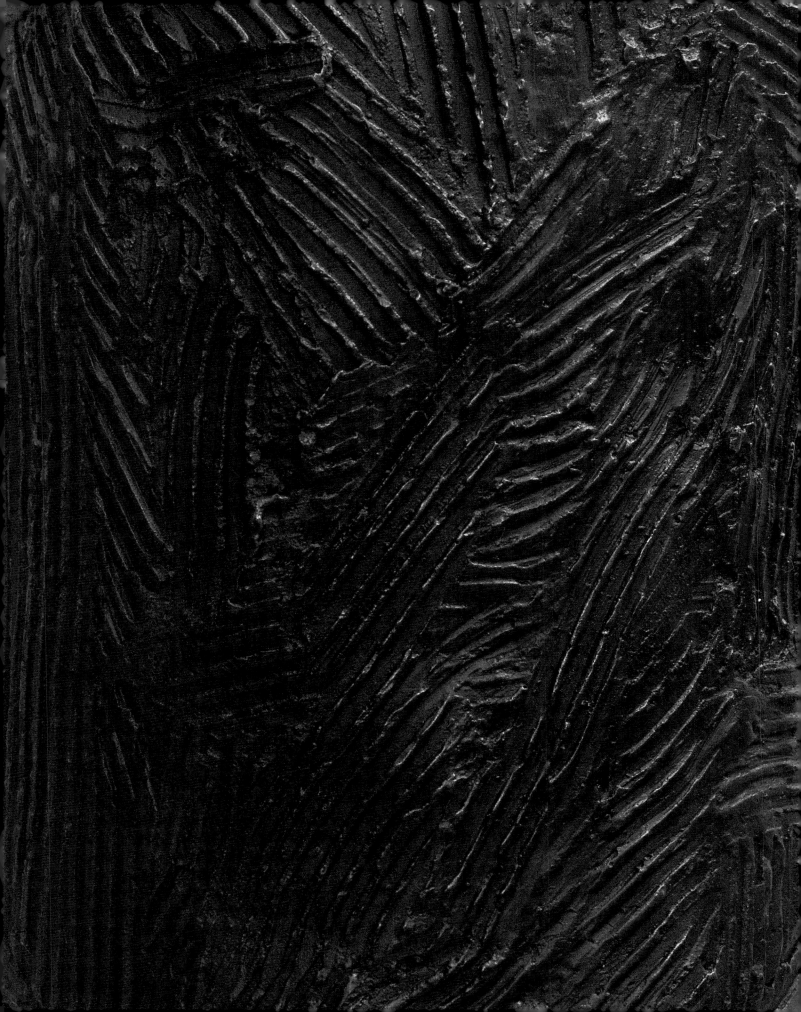

lowest it is some form of egocentricism.
At its broadest it is the percolation of a
whole culture through the artist who
acts as a receptacle. There is a powerful
affinity between the tribal icons which
have held communities together in our country
for centuries. You grew up amongst them
and these powerful images have persisted
in your memory and now appear in the
guise of your sculpture. They are not fragile
and emit an aura to keep evil at bay.
This is not idle arty talk because even in an
age of reason there is a deep seated notion
that there are forces beyond our comprehension
and control which need to be placated. These
images are therefore not to be seen as objects
to grace a drawingroom but as votive offerings
occupying sacred space.
      I mention these sculptured heads as only of
a kind amongst the infinite concepts which
find their way magically through your fingers.
      I am entranced by the linear element
which you have introduced on some of your
sculptured heads. It is not a superscription
but seems directed by the formation of the sculpture
giving direction to the eyes which behold it.
There is so much more which breathes of your free
spirit. May it always be so.
                                    Krishen Khanna

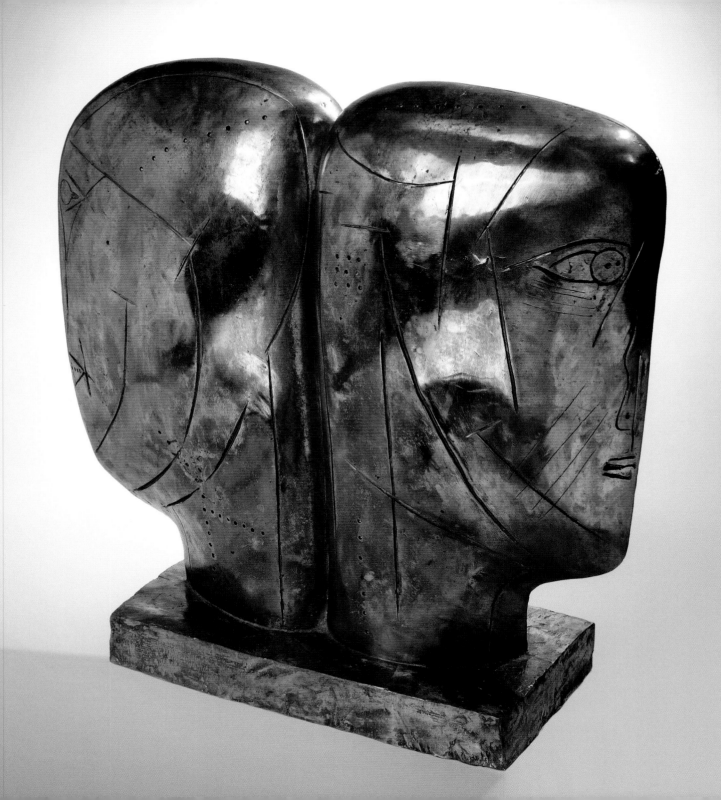

# An Unreasoned Act of Being
## New Sculptures by Himmat Shah

*Gayatri Sinha*

*Art is neither conformity to reality nor a flight from it, it is reality itself...*
*the threshold for the passage into the state of freedom.*
—*Manifesto*, Group 1890, 1963

No discourse on Indian modernist sculpture would be complete without according a central position to Himmat Shah. As draughtsman sculptor, Himmat's practice of over four decades displays a rare intentionality, one in which anything but the true – and by extension, the pure – should be vigorously evacuated.

The larger-than-life bronze heads that we contemplate in the present exhibition bear an imprint that makes their locus a hermetic puzzle. Their sudden monumentality bespeaks a presence both cranial and phallic. On their bodies appear marks like those of journeys of the past, like a trail etched out across the Hindukush mountains or the salt flats of Gujarat, perhaps, tread by weary travellers as they traverse a death-defying trajectory. Or, perhaps, they are mammoth puzzles of the human condition and its existential states that defy simple definition. "The human being is an enigma and what he creates should also be an enigma."

In conversation, Himmat appropriates for the artist the role of bohemian interlocutor committed to a poetic expressivity. He speaks of artistic influences and

Pages 10 and 13: **Bronze, 28 x 28", Edition of 5**

childhood memory as goalposts that illuminated the way. But at best, the details he provides only flag a selective journey, leaving much in the grey area of the unstated. By the time the ideologically drawn Group 1890 was formed in 1963, vigorously articulated by artist-ideologue Jagdish Swaminathan, Himmat Shah had assumed the position of a modernist engaged in the quest for a language. As a founder member of Group 1890, Himmat would have subscribed to its manifesto, and its self-avowed "search for significance between tradition and contemporaneity, between representation and abstraction, between communication and expression." Octavio Paz, who wrote the foreword for the group's only exhibition, described their energetic quest for the Encounter, the creative act which "demands a sort of asceticism, a rigour without complacency." Paz also wrote what, in retrospect, appears to be prophetic of Himmat's art, "The true subject of this exhibition is the confrontation of the vision of these painters with the inherited image. Contemporary Indian art, if this country is to have an art worthy of its past, cannot but be born from this violent clash." This event would have intersected the life of the young artist, and the trajectory his practice. At 30, Himmat Shah had already gained attention in India's mononuclear art world with success at the only national award for painting, in 1960 and 1962, as well as the Bombay Art Society Award in 1960. These early awards recognized the maturation of a talent that is indivisible from his life and practice.

Born in Lothal in 1933, into a Jain mercantile family, Himmat appears to have spent his childhood in deep absorption of familial influence, even as he resisted familial ties. Prophetically, several years later J. Swaminathan was to describe him in the *Link* "as a bird who has forgotten how to stop migrating." Traditionally, Himmat's forefathers had traded in cotton and owned farmland, including some of the sites excavated at Lothal. His grandfather, a trader who also practised the ancient Indian medicine system of Ayurved, fascinated the child with his books and potions, with their alchemic possibility of transforming the nature of substances. Even as a Jain with stringent notions of purity, his grandfather worked with herbs and snake poison; tempered and transformed in earthenware pots in the kiln, these were the boy's first experience of alchemic transformation. A wayward child,

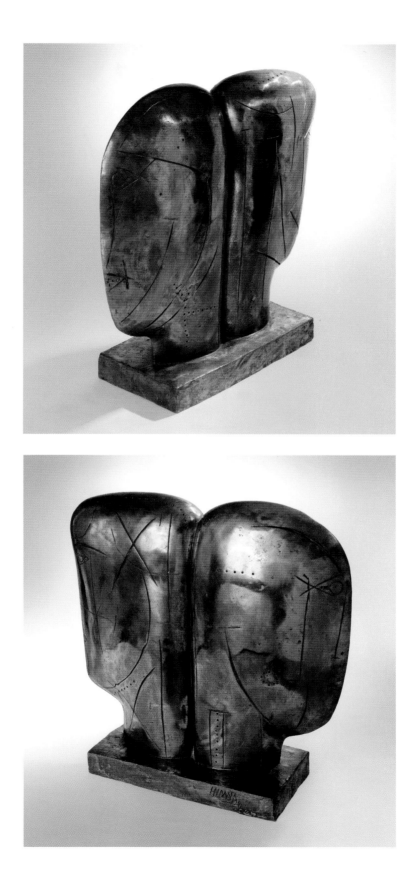

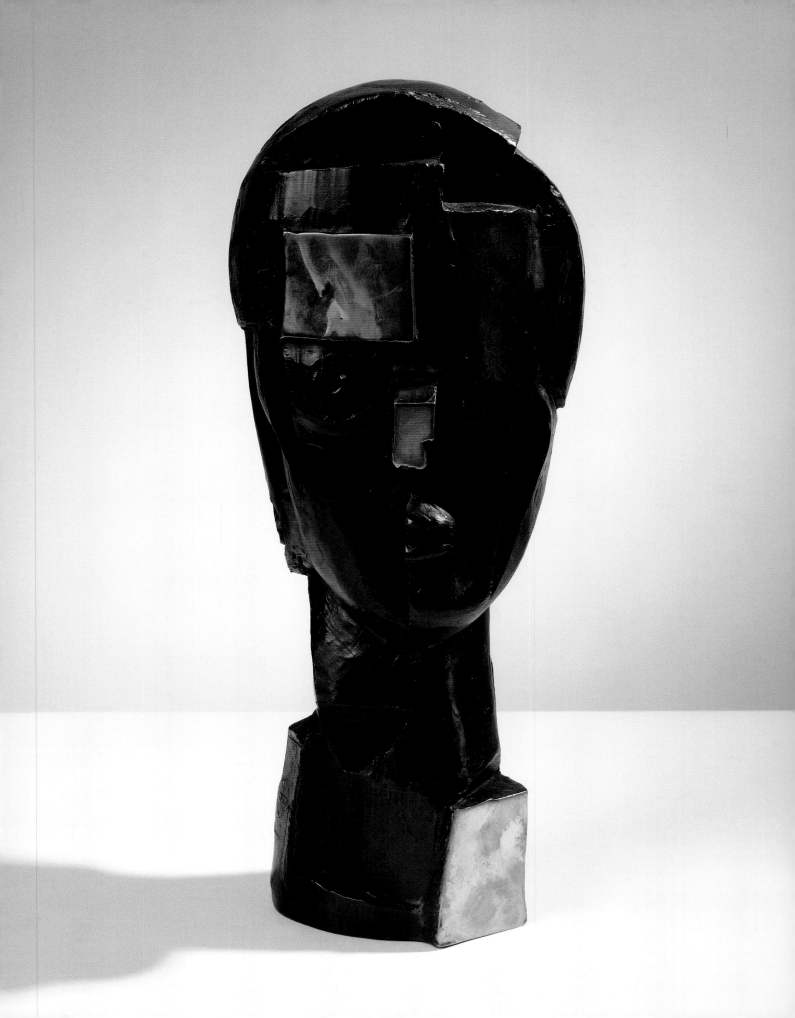

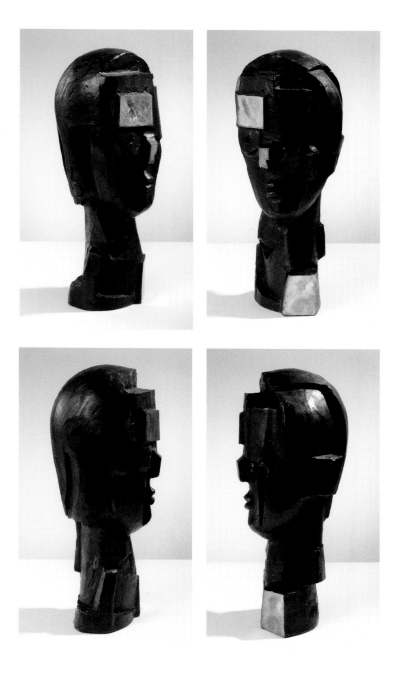

Bronze, 17.3 x 7.1", Edition of 5

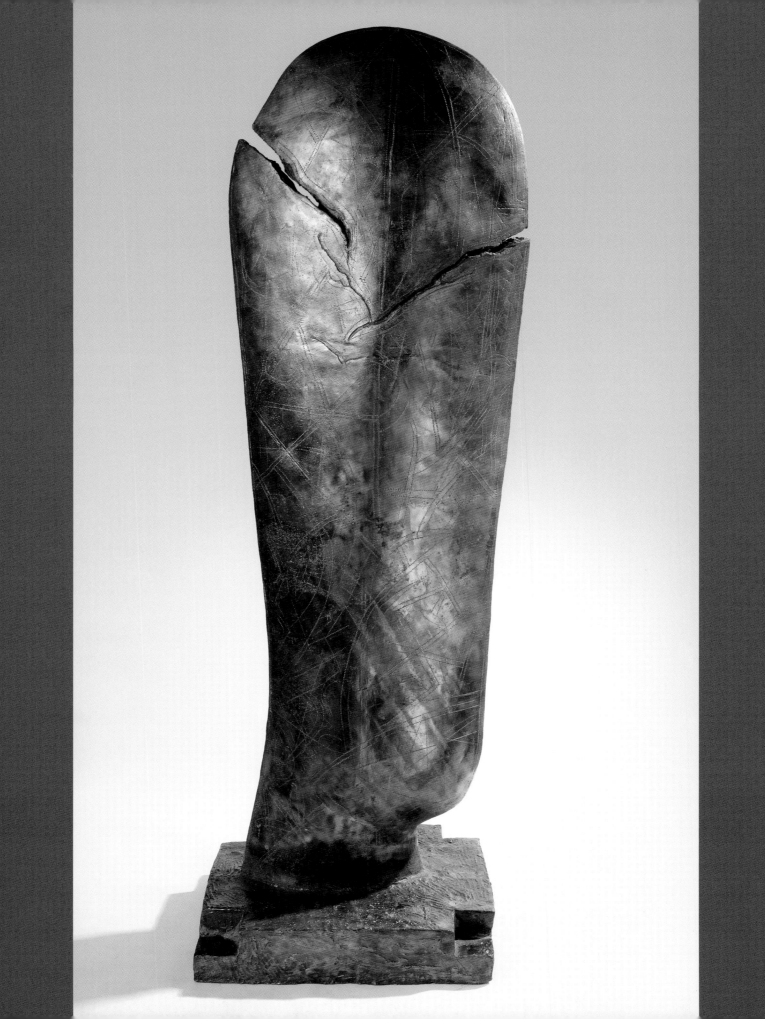

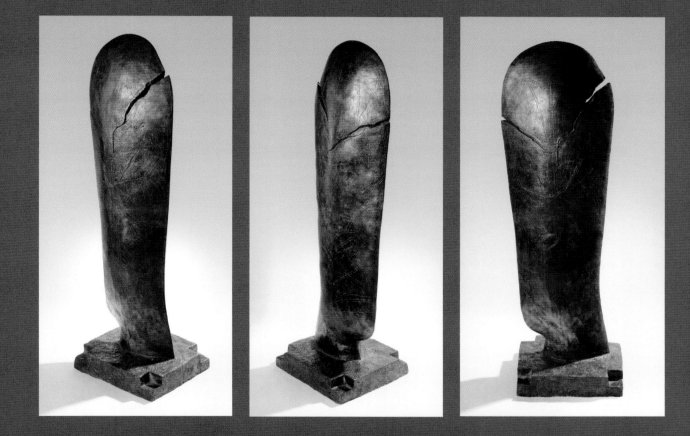

Bronze, 58.4 x 21.3", Edition of 5

Himmat would refuse to attend school and instead rode with his family servant, Sula Bhagat, on horseback to attend itinerant *bhajan mandali* or *bhavai* performances, absorbed in the theatre of the recitation and the power of the performance. He would also run to play in the potters' colony and bring home to his grandmother the everyday objects that his fingers had shaped.

At home, however, the family fortunes had faltered, fissures and cracks appeared in the large joint structure of extended uncles and cousins. As the excavations at Lothal, a Harappan site, became institutionalized, some of the family land was appropriated. Himmat's response was to frequently run away into the Girnar forest, with the journey becoming a metaphor of protest. In a Junagadh *goshala*, or cowshed, he painted images of Ram on the temple and sold the occasional drawings. In this period of strange discontinuities, Himmat appears to have acquired the life-long habit of paring down his needs of living and working with remarkable economy. Finally, his family sent him to the *Gharshala* or home school of Dakshinamurty, a centre that attracted boys from the Kathiawadi region with its Gandhian philosophy and open system of education.

At Dakshinamurty's school, Himmat trained in art under Jagubhai Shah, a teacher of Gandhian persuasion. In the period preceding Independence, the values of self-reliance and a rejection of western methods powerfully percolated through the Indian school system. In these early years, Himmat's propensity for drawing was both natural and necessary. As an inexpensive, transformative and free form of expression, it would have appealed to him in his negotiations with form and space. At the age of 19, Himmat went to Ahmedabad to meet the by then iconic figure of Rasiklal Parekh, senior proponent of the so-called Gujarati *qalam* or style.

At about the same time, he heard of N.S. Bendre who, as a reputed artist, had taken over as head of the Department of Painting, M.S. University, Baroda.

Pages 19–21: **Bronze, 36 x 12", Edition of 5**

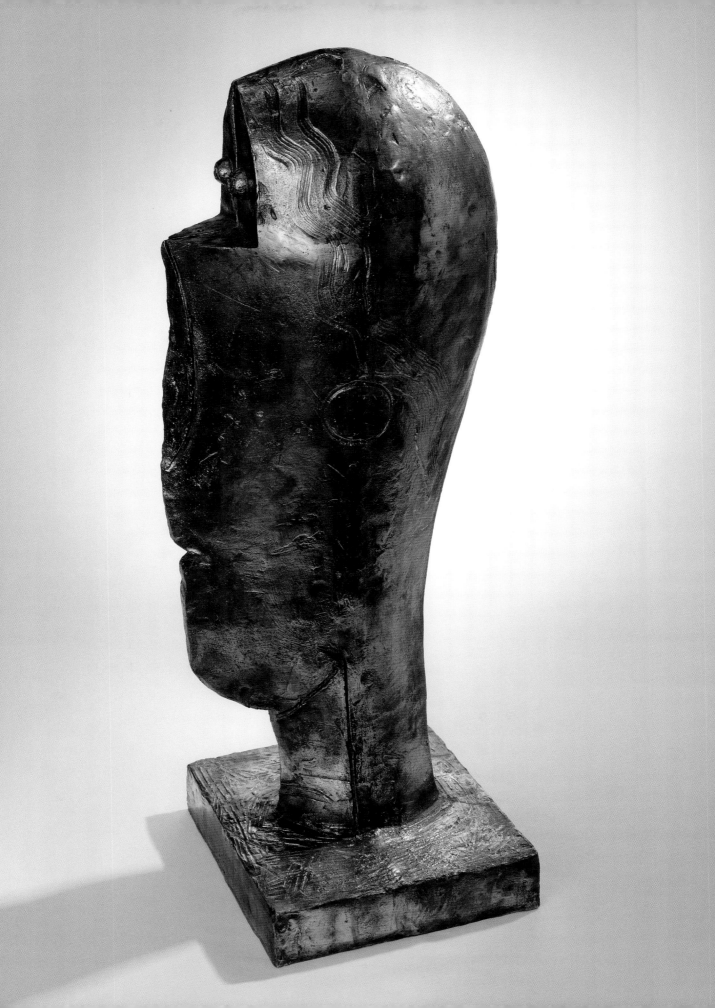

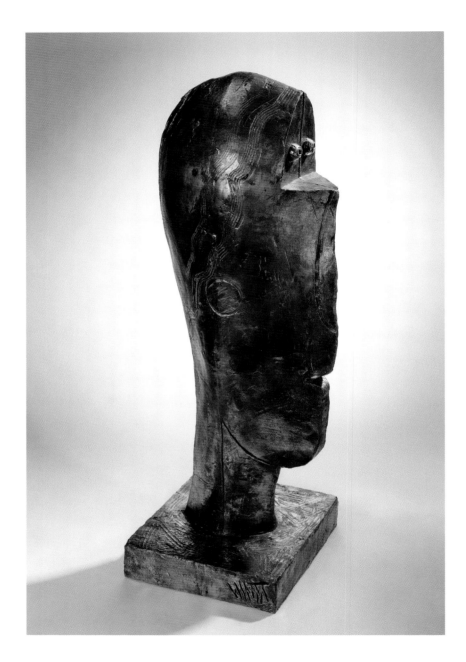

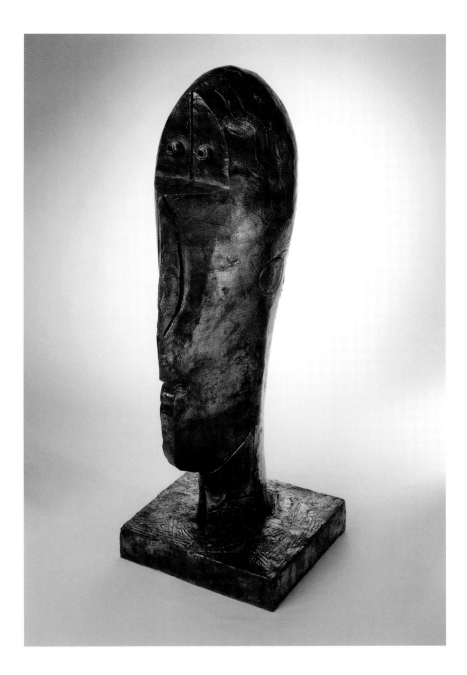

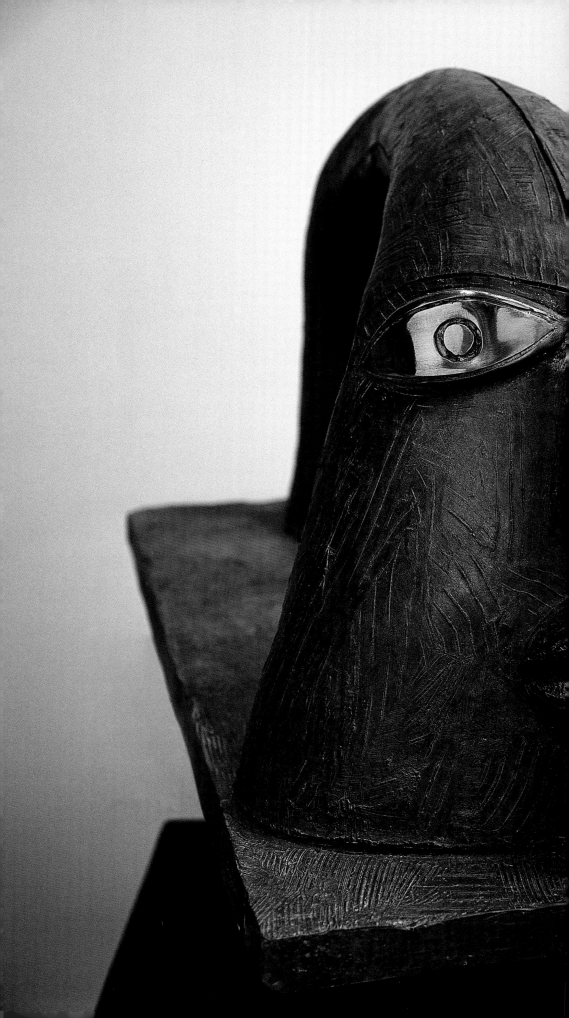

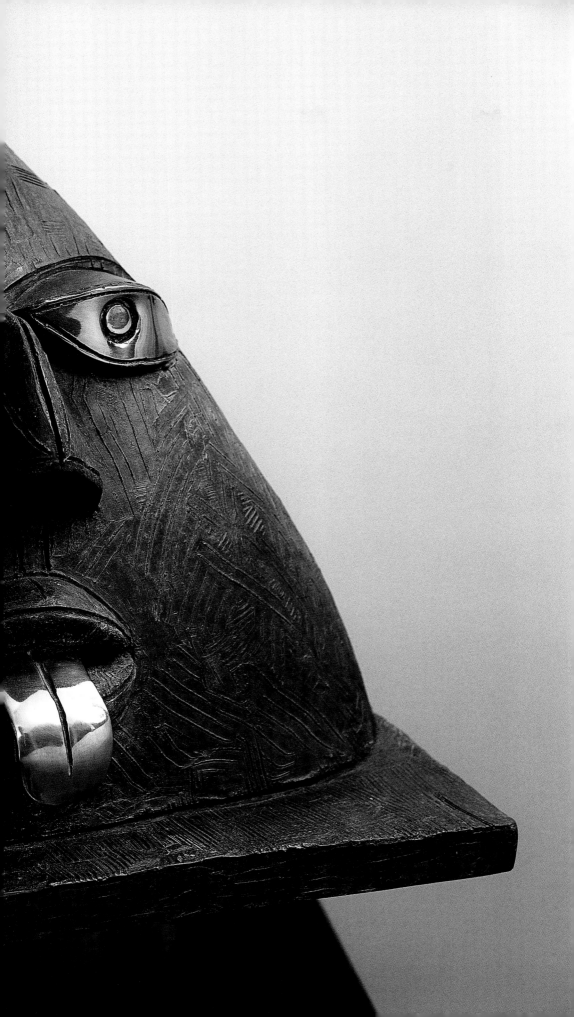

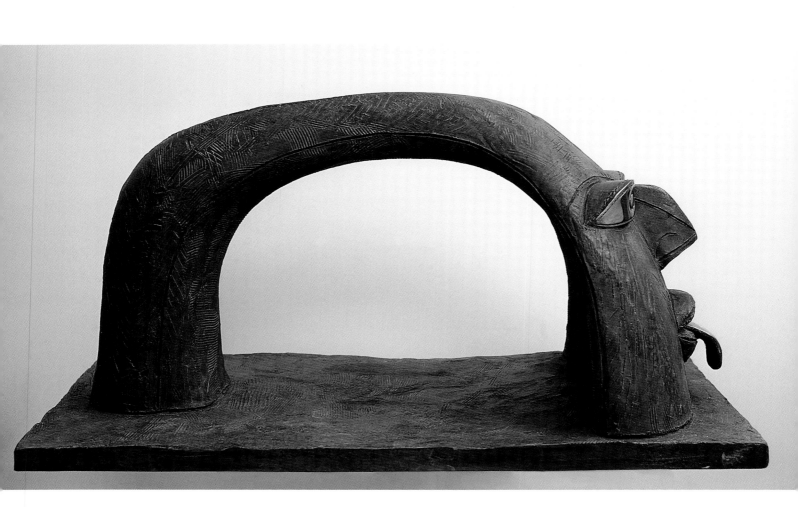

Pages 22–24: **Bronze, 11 x 20.5", Edition of 5**

Bendre's particular position as a polymath of mediums and styles had already earned him a wide reputation. Nilima Sheikh, eminent artist and alumna of the school, writes, "He had deft control over whichever medium he chose – charcoal, crayon, watercolour or oils." Himmat, who studied at Baroda between 1955 and 1962, was among the other outstanding *Gharshala* students – Jyoti Bhatt, Narendra Patel, Prafull Dave, Kishor Parekh – who had the benefit of instruction under Bendre.

Himmat's interlude at Baroda was under the towering influence of N.S. Bendre and K.G. Subramanyan. The first, an uncompromising modernist who believed in the principles of cubism and abstraction, the second, an inventive folklorist who liberated the artist through the many byways of India's own cultural hinterland – both were probably equally influential in moulding Himmat's vision. Nevertheless, he seems to have developed rapidly out of the art school situation into an area of self-expression and interpretation of materials. In 1962, Himmat came to Delhi with the artist Balkrishna Patel. In the early 1960s, artists in Delhi were content with a smattering of art schools and only skeletal support from the National Art Academy. Here, Himmat met the influential artist-ideologue Jagdish Swaminathan, and with him and other artists he founded Group 1890; together, they dedicated their exhibition "to the memory of Georges Braque." The Group, which encouraged Indian art to sharply manifest an identity distinct from the schools of Paris and New York, created a significant rupture in practice. Himmat himself created a memorable stir with his very first drawings, exhibited in Delhi in 1964. Boldly erotic in their animalistic energy, they drew a comment from Swaminathan: "The creatures frantically engaged in the compulsive act of sex are bereft of all humanity; wallowing in primeval slime, they have grown into grotesque monsters whose sole preoccupation is the procreation of a species condemned to extinction." With Group 1890, Himmat showed burnt and charred paper collages, work which earned praise from Octavio Paz.

Himmat's own engagement with an international modernism was fostered by the two years that he spent in Paris (1965–67), studying and travelling around the museums of Europe. "At that time I was full of inhibitions and complexes; I couldn't speak English or French. But I went everywhere. I must have studied ten

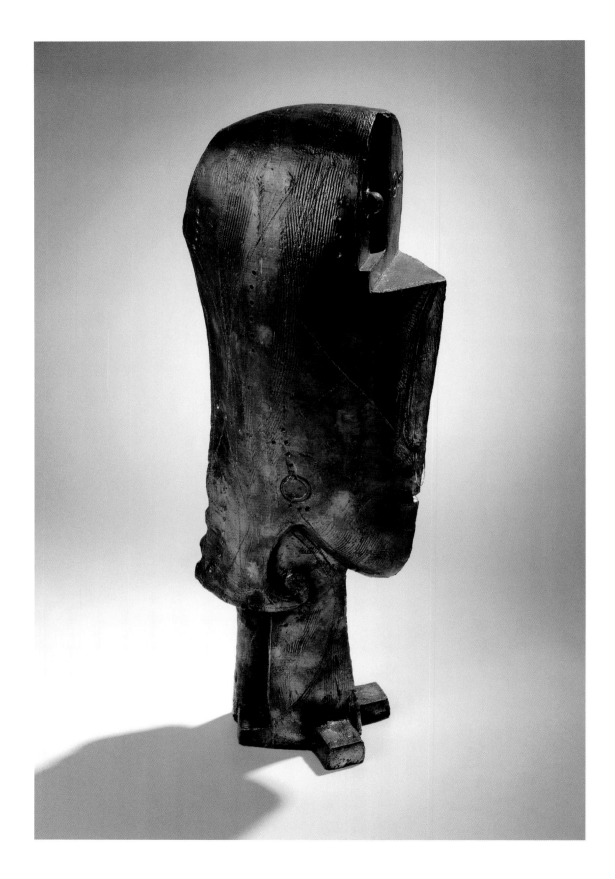

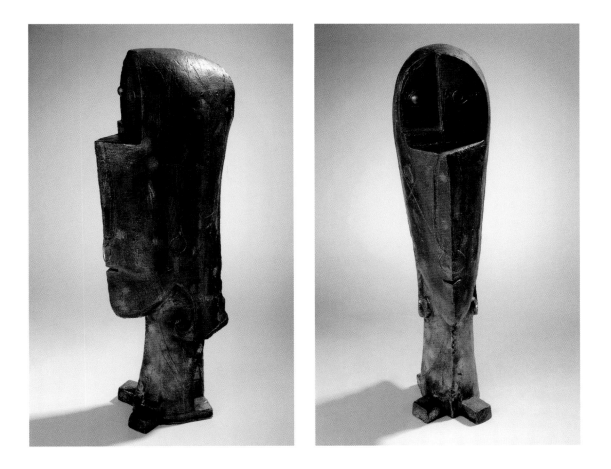

Bronze, 33.5 x 8", Edition of 5

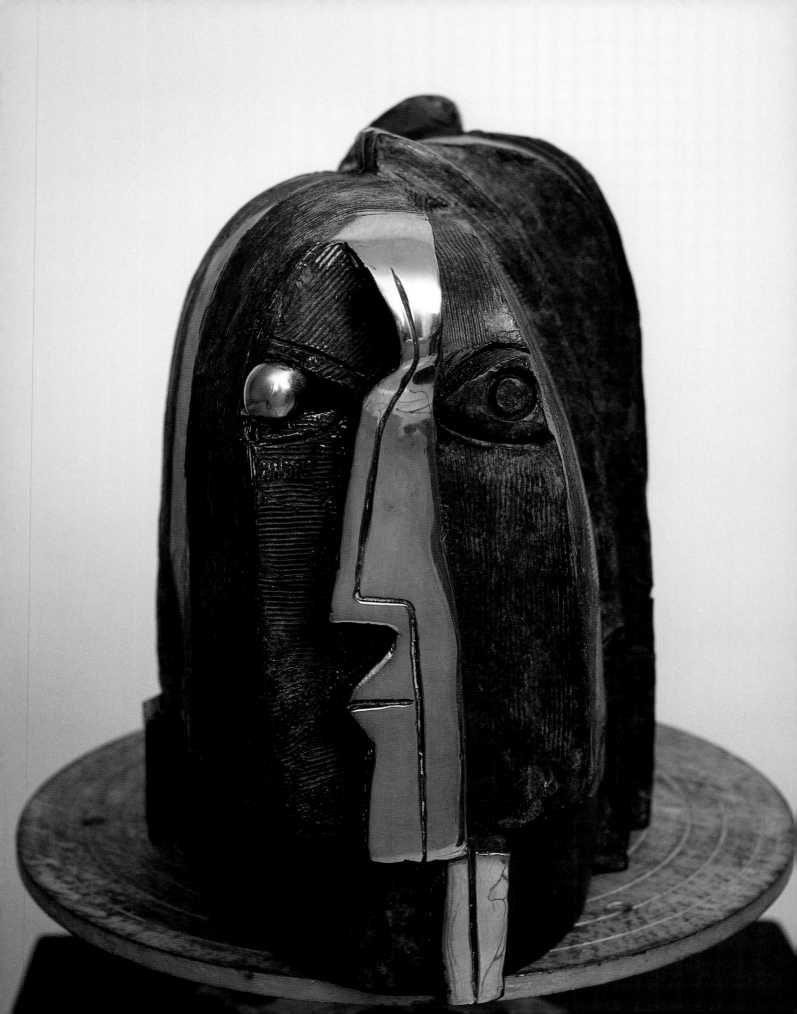

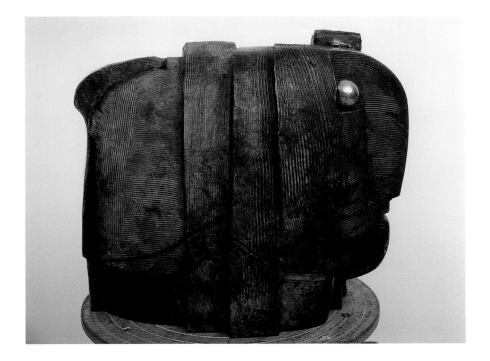

Bronze, 11.5 x 9.5", Edition of 5

thousand paintings. I used to study Rousseau and then run away in fear. Rousseau changed my sense of scale." In his journey, he would have had the opportunity to study modern masters like Klee, Picasso, Brancusi and Giacometti, as well as Tapies, whose influence is evident in Himmat's paintings. The 1960s was the decade of printmaking in India, facilitated by workshops organized by the Lalit Kala Akademi. In Paris, Atelier 17 had galvanized the printmaking world with its energetic experiments in colour viscosity and multiple images. Himmat studied etching under S.W. Hayter and Krishna Reddy. As a medium, Himmat would use the surface effects of printmaking on his sculpture, revealing an ability to dynamically interpret different materials.

Such biographical detail in the case of an artist like Himmat can only mark, like material goalposts, the visible imprint of the journey. But it is in the gentle unseen interstices of emotion and spirit that the artist seems to reside. For over two decades now, Himmat has demonstrated his leading preoccupations, primarily in drawing and sculpture. If one stands back to take a telescopic view of his sculpture, it would probably fall in the areas of enigma, domesticity and sheer whim. Himmat turns conventional scale into a mockery and allows for sheer play to dominate his vision, wherein architectural structures are dwarfed and heads enlarged to an enigmatic monumentality. Where waste, the detritus of man's passage on earth, is reinscribed into new forms and gains a lasting vitality. And even though he works with tangible matter and surface, Himmat appears to draw from the elements, entrapping the movement of water and fire in terracotta, or the movement of the hand and the tempered breath on the gradually cooling surface of bronze. This suggestion of human and natural presences permeates his transactions with history, petrifying within it the presence of shifting time and space.

Let us briefly consider Himmat's engagement with historical time. As a youth, he would have witnessed the freedom of India. At the same time, as a boy

Pages 31–33: **Bronze, 36.6 x 12.2", Edition of 5**

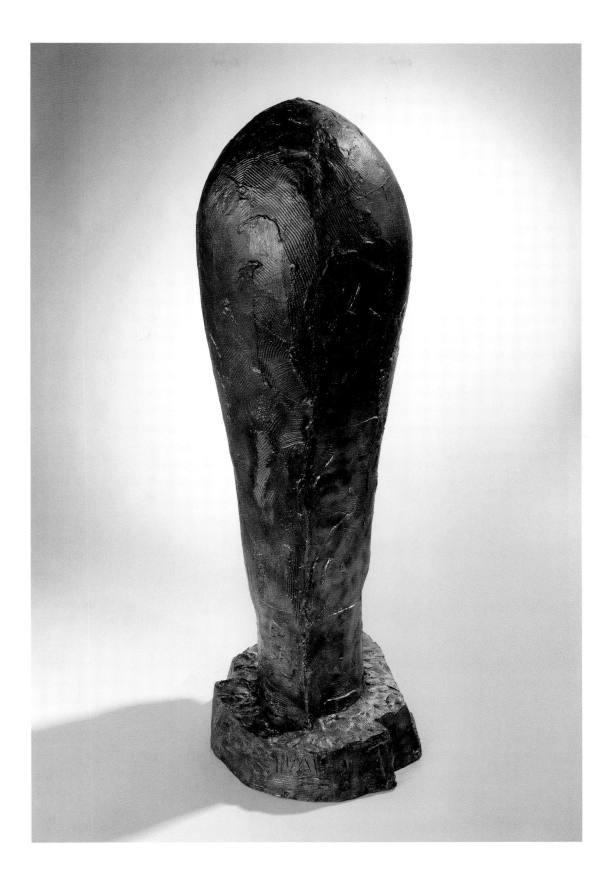

growing up in Lothal, Himmat would have been familiar with some of the enigma and historic challenges that excavations of the Indus Valley Civilization proposed. Such as the Mother Goddesses, like those found between Persia and the Aegean, full-breasted and neatly coiffed, in terracotta and faience, but which appear without the presence of a temple. Or the first known appearance of Rudra-Shiva on seals, both iconic and phallic, possessing and documenting the spheres of the conceptual and the material in a single form.

Himmat's leading experiments are not restricted to scale; they also permeate his understanding of historical time and space. If Himmat engages the remnants of the past with the palpable present, he also encourages and coaxes out other narratives from the detritus of the earth's surface. On his return from Europe, Himmat's early work indicated his chosen path. It comprised a group of free-standing sculptures in terracotta and stoneware-flags with a totemic feel, clusters of forms that mimicked life in an ancient settlement perhaps, creating an echo of what Prayag Shukla describes as "our villages, our ancestral homes, and our racial memory."

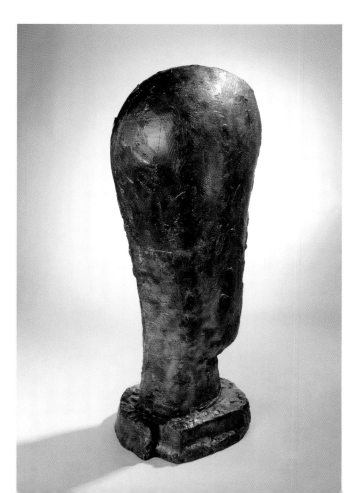

The artist reclaims the past to inscribe it in the present. Here, Himmat's choice of objects from the streets of the city and the fields is one that marks survival, that initiates an inquiry into the container/womb, the seed/bulb, the pipe/flag/totem/tree. Like his heads, these forms do not reveal through narrative or association, rather, they engage us as subjects of contemplation and transformation. There is wonder and contemplation in these miniaturized forms, as if in their making Himmat participates in the earliest village settlements, in the urge to tame and domesticate the elements.

Himmat appears to have arrived at his chosen image field – one that is both narrow and expansive – through a process of prolonged observation. For a long period of his life, he lived and worked in the Garhi artist studios, or rented *barsaatis* in Delhi, surrounded by what he made and what he chose to look at. The artist Krishen Khanna, who also worked out of the Garhi studios, described Himmat's workplace in the 1980s: "His studio is a storehouse of objects he has picked up and which outgrew their use and found their way to junkyards and the rubbish heap.

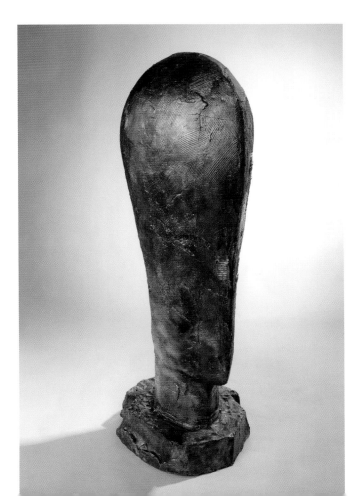

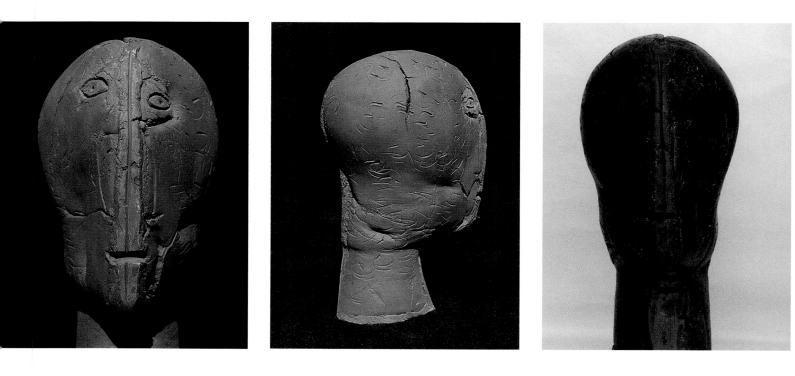

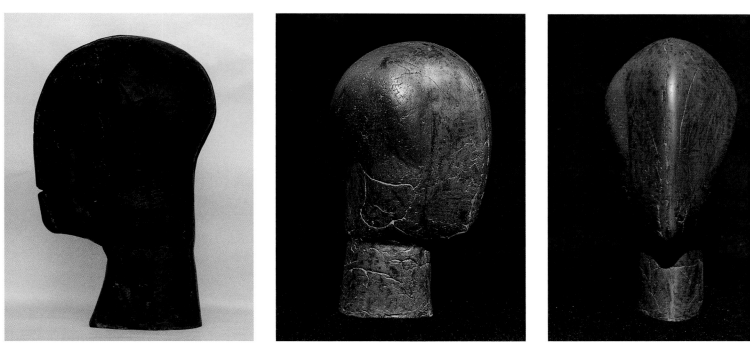

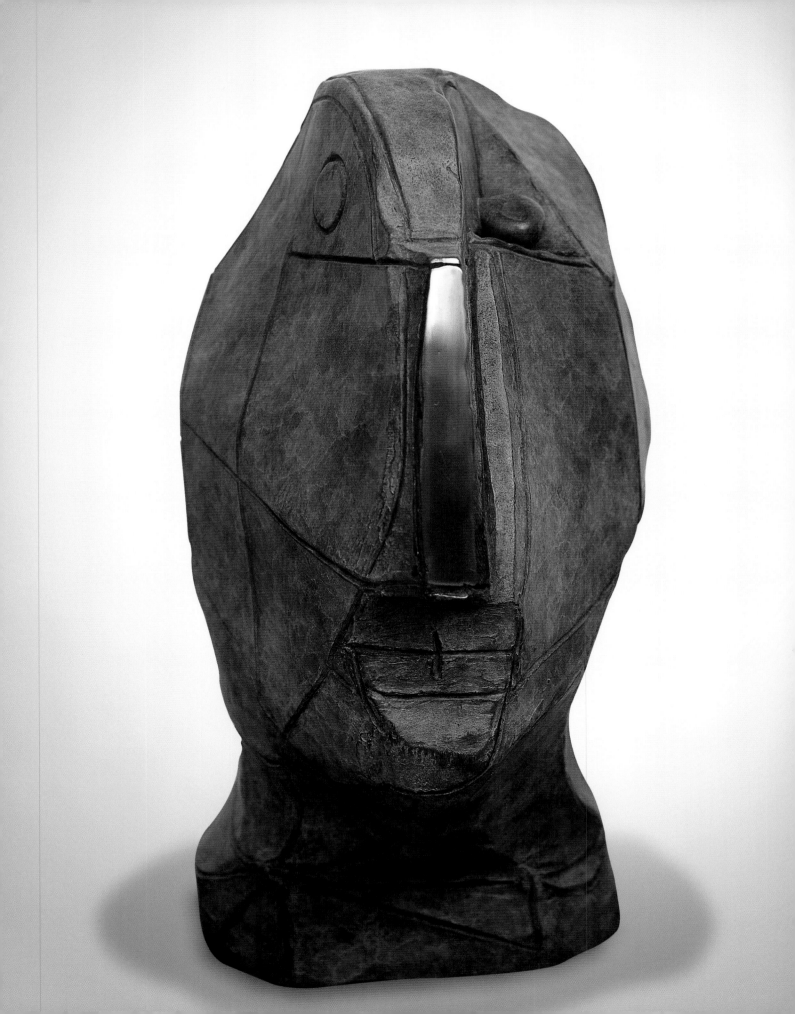

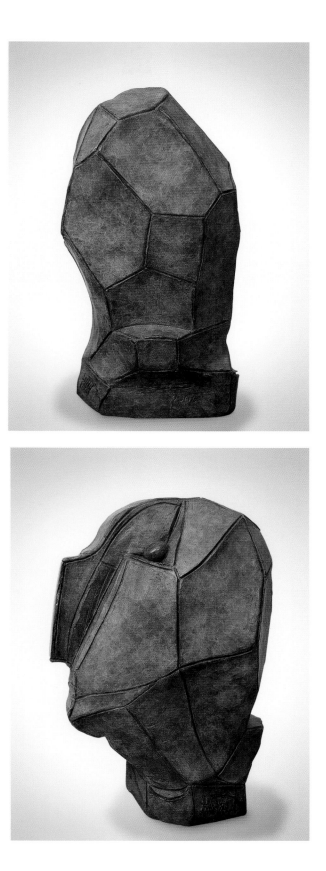

Bronze, 12 x 8", Edition of 5

Old bottles, bits of metal, knives of all sorts, wires, ropes, pots and pans, all resuscitated and given a new status, coexisting happily with clay, plaster, pigments, chemicals. Heads at various stages in the making. All, including him, covered with a fine white dust. It is more like a magician's cave than a conventional studio." In his studio broken bottles, plant bulbs, kettles, pipes and taps, residual roots, cups – the detritus of man's presence on earth – found a new locus for contemplation. Here, they coexisted with clay retrieved from the Yamuna, clay that lived and breathed until he was satisfied with its new-old texture. Years later, these found objects may be used in a sculpture emphasizing again Himmat's transformative view of materials. This process also endorses his practice of using material not as an object, but as extensions of the self that accrue and dwell in his living space (for Himmat has always lived in his studio) before they mutate into other forms.

There is also Himmat's engagement with materials which, in a sense, mimics or reflects his attitude towards the artists' place in society. The vast dry fields and excavated innards of the site of Lothal yielded what has come to be expected of every site of the Harappan civilization – bricks, weights, neatly laid out city streets, domestic and divine terracotta figures and seals with anthropomorphic figures of worship. Himmat's favoured material is terracotta, a material that reflects India's longstanding village economies, supported by the cycle of the birth and rebirth of the essential material, clay. Only some terracotta objects pass into history, many do not bear the imprint of the artist, and all speak of the early wonder of man mimicking nature. It is entirely possible that Himmat's response to clay, which needs the other elements of water and fire to gain form, is at the level of the philosophical, as much as of the material.

Further, no matter what value accrues socially to materials, in the transformative hands of the artist, they undergo a magical renewal. In the traditional Indian system, materials have been imbued with fixed meaning: gold with health, silver with fame, copper with progeny and so on. In the hands of a modernist like Rauschenberg, the relative and even conflicting value attached to material – gold foil over mud, for instance – is further explored. In working found objects into his sculptures,

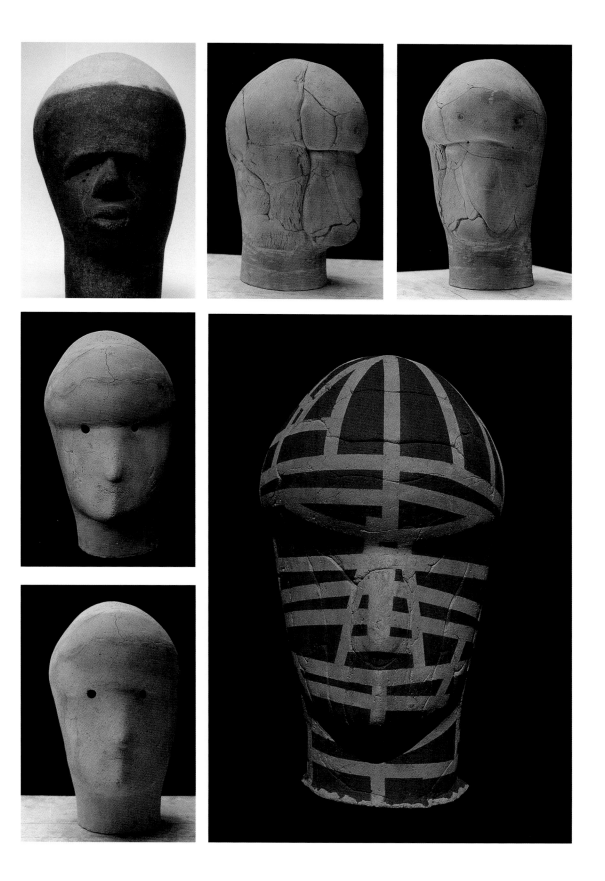

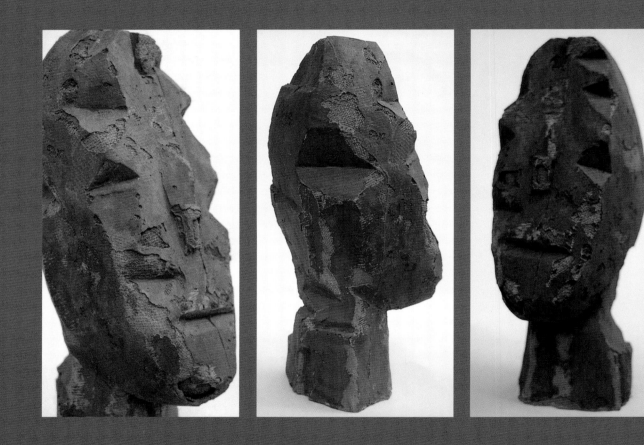

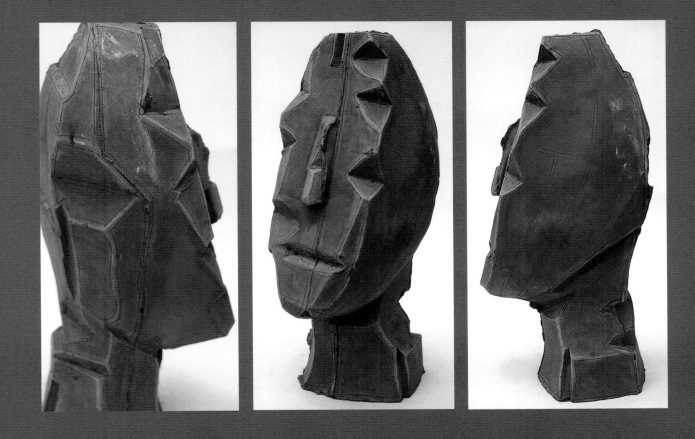

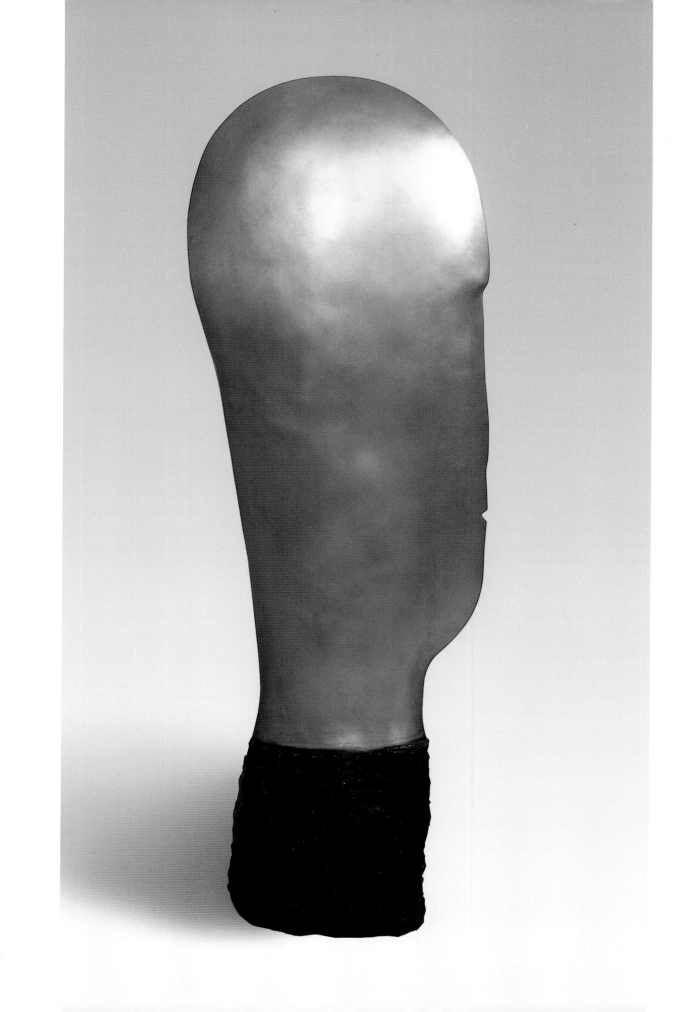

Bronze, 52 x 10", Edition of 5

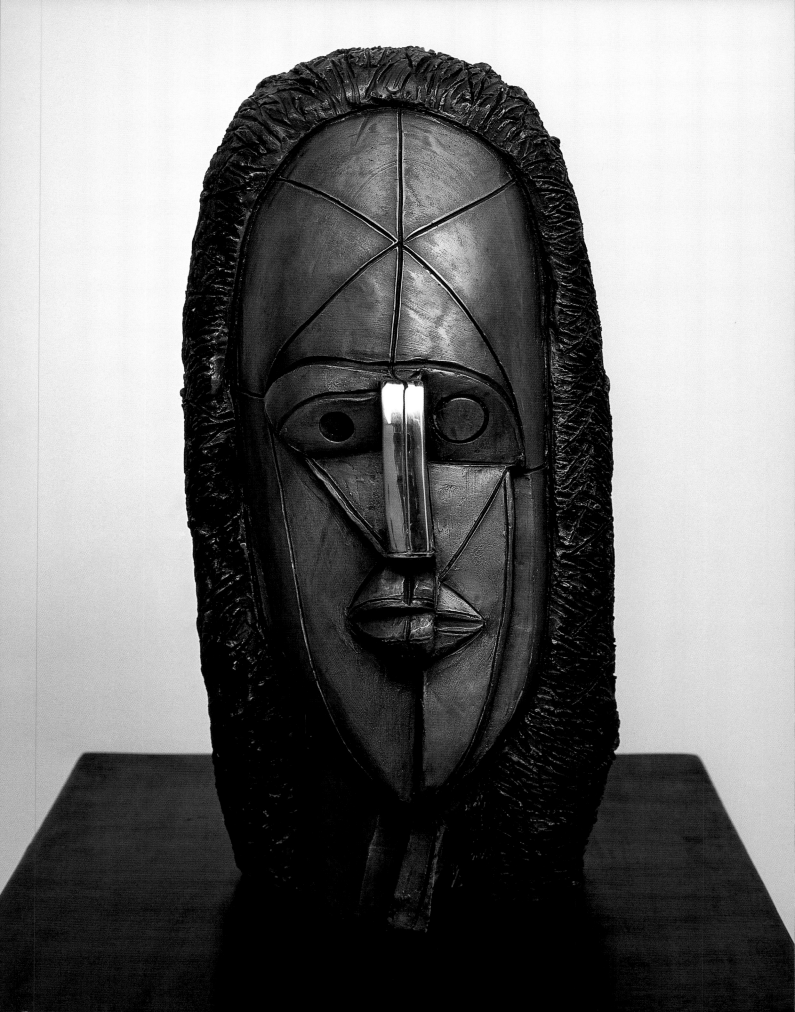

Himmat engages with form rather than value, association rather than object, leading the viewer into a laterally expansive view. Again, by combining gold foil with baked terracotta, he expands the way in which material is interpreted and received. Like other successful sculptors, Himmat's drawing and sculpting have continued simultaneously, volume working in a dialogic interchange with line. While the drawings appear to spill outward in gestures that are lyrical and free, setting up propositions and questions that appear to push beyond the frame, the sculptures are contained, inward and resistant.

> "Just as copper melted by fire and poured into a mould takes that very shape,
> so does the mind take the shape of the object comprehended."
> – *Upadesahasri* (XIV, 4), Sankaracharya

Himmat Shah's suite of large heads comes at the apex of his investigation of the human condition. There is nothing in the Indian sculptural tradition that leads to the making of the head as a discrete sculptural form. But there is a residue of broken busts; ancient contemplative Buddhas that line whole floors of Indian museums, studies in stillness, long after the Buddha's presence had been eroded from the land of his birth. Or else, the *Mukha-linga*, which combines the ithyphallic lingam of Shiva with his face, creating a palimpsest of concepts and material icons. In this figuration, the head/face gains as a conceptual whole from a superimposition of body parts.

In his construction of the head, ancient presences are suggested, like atavistic shadows. More accurately, Himmat arrives at what Nilima Sheikh describes as "the projective voluptuousness of the image." Here, as the artist perceives it, the head, the phallus and the pillar are all the same; the sculpture gains its vitality not in its definition, but in the process of arriving at a form. These works appear to re-echo the passage of civilizations, recalling early migrations between Africa and India,

Pages 44–47: **Bronze, 17 x 9", Edition of 5**

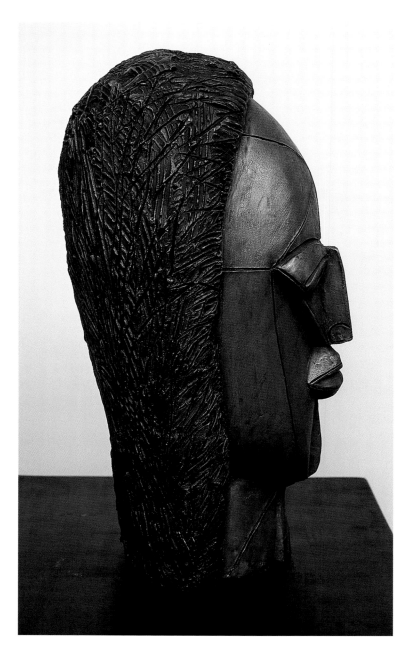

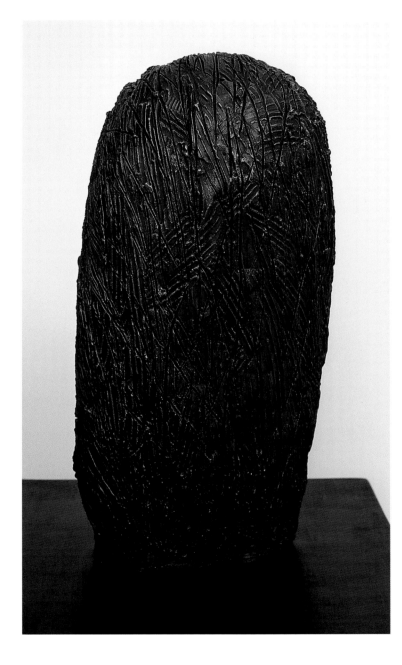

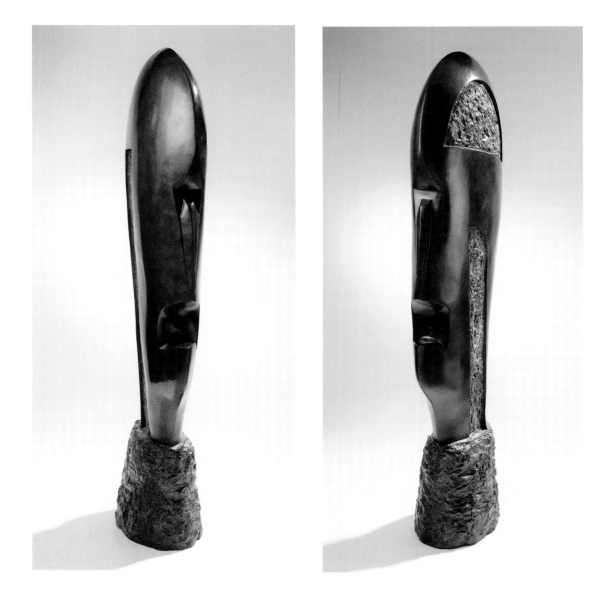

Bronze, 52 x 10", Edition of 5

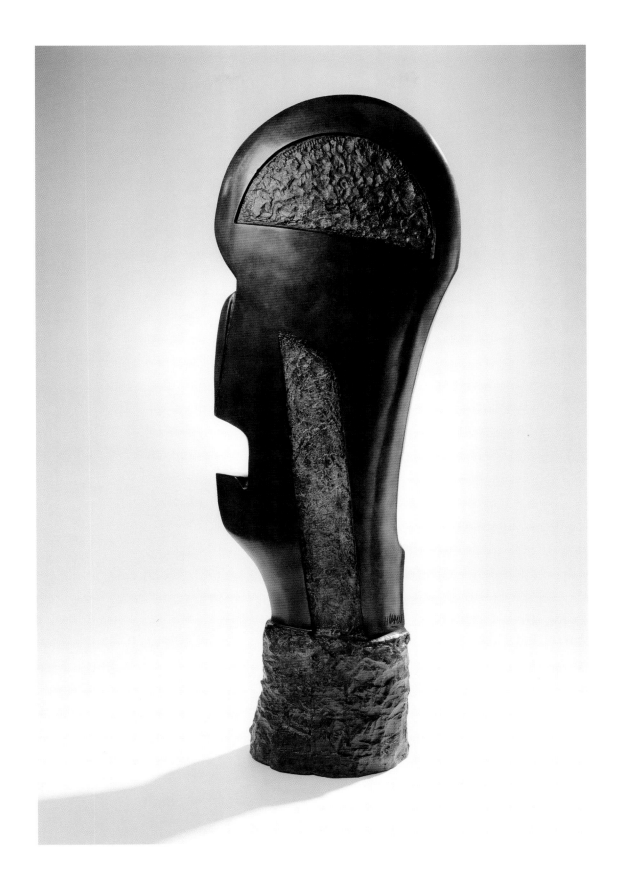

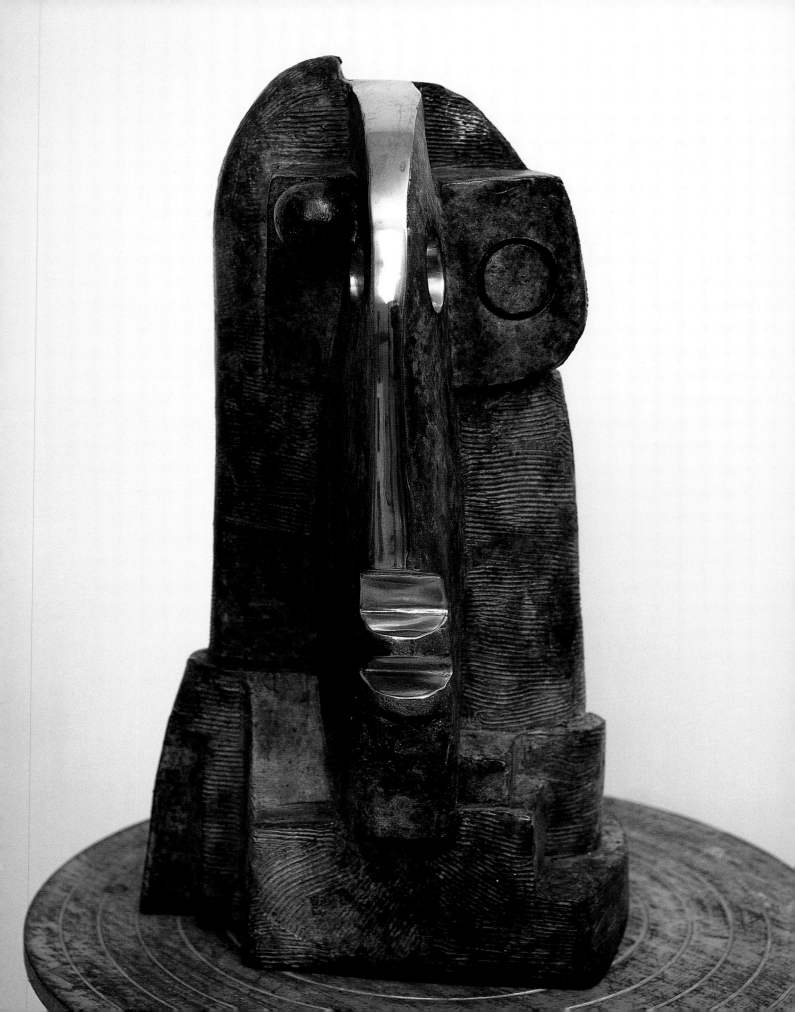

to ancient seaports like Lothal, perhaps. Occasionally divested of features, they present models of classical introversion, of the gaze turned inward, still and contemplative. Like the Tirathankaras of the Jain tradition, each form presents a transformative emotional state, of becoming rather than being, one where *udaasi* or sorrow is transformed in joy. Nevertheless, it is also an intensely modern state, one that avoids any visible narrative or expressivity. Stubborn and unrelenting, these heads become expressive of a state of resistance, one that bears the marks of isolation perhaps, but also of a commitment to life and endurance. What the images do reveal are fissures that suggest the alchemic wearing away of the form, affected by heat and time, mimicking the clefts and cleavages of the body. The relationship with alchemy signifies as hermetic knowledge. In the welding together of the *panch mahabhutas* (the five elements – air, water, fire, earth and ether) we not only approximate Brahman, but also his highest creation, man.

The heads also bear the marks and grooves of an experiential mapping of tentative tracks and journeys. In the surface of his forms, Himmat recalls the craft techniques of his native Saurashtra, its strong linear pictorial/pictogramic style, and the exposed stitched embroidery of its womenfolk. These striated marks appear like a domestic activity as much as a cartographic plotting of vast journeys across the surface of the earth. In choosing to work with bronze casting, Himmat also draws on the associations of maleness and iconicity. But in choosing casting above constructed sculpture, Himmat allies with the suspension of time, and the continuity of an ancient tradition. In a sense, his works are portraits, but their locus draws from past and present, generic and individual man. The patina, furrows and the sharp cleavages of long years of human experience are visible, as Himmat invites us to share in a monumental quietude and the fraternity of being human. At the same time, the stillness of the image offers a sense of its perpetual entrapment and silence.

Pages 50–53: **Bronze, 10.5 x 7.5", Edition of 5**

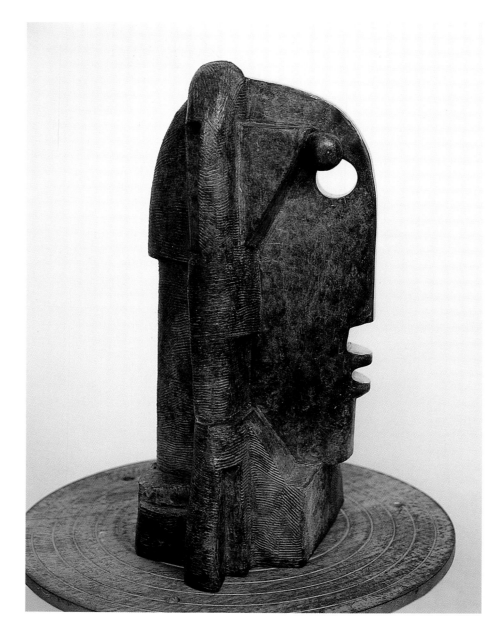

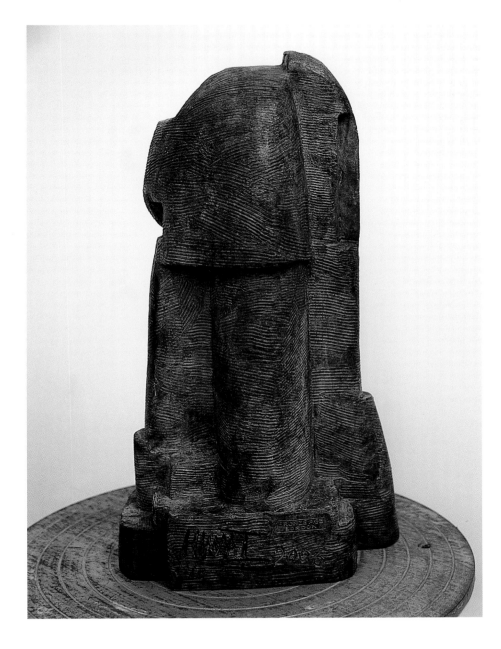

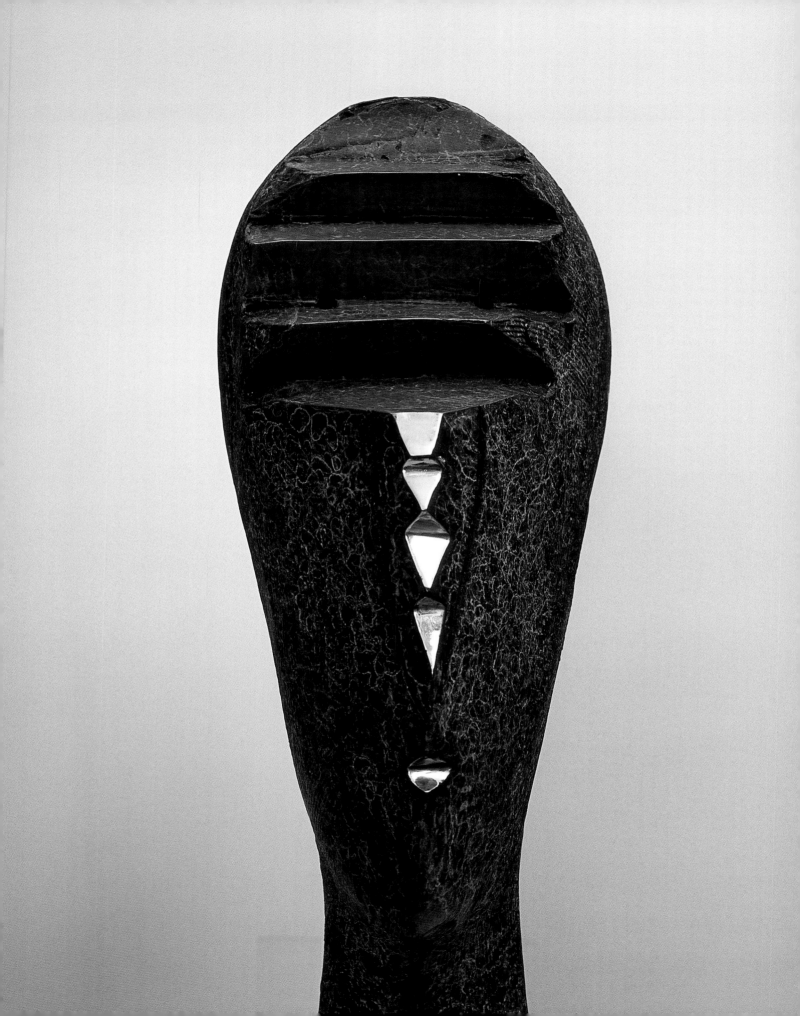

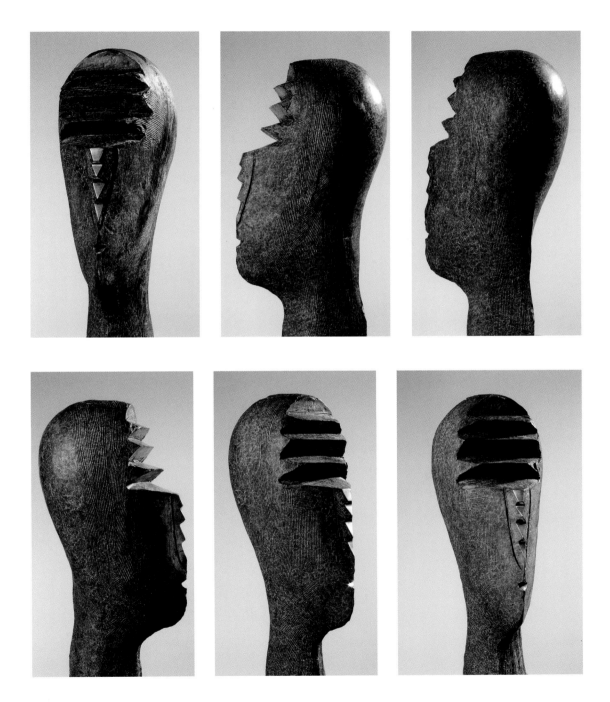

Bronze, 21 x 8", Edition of 5

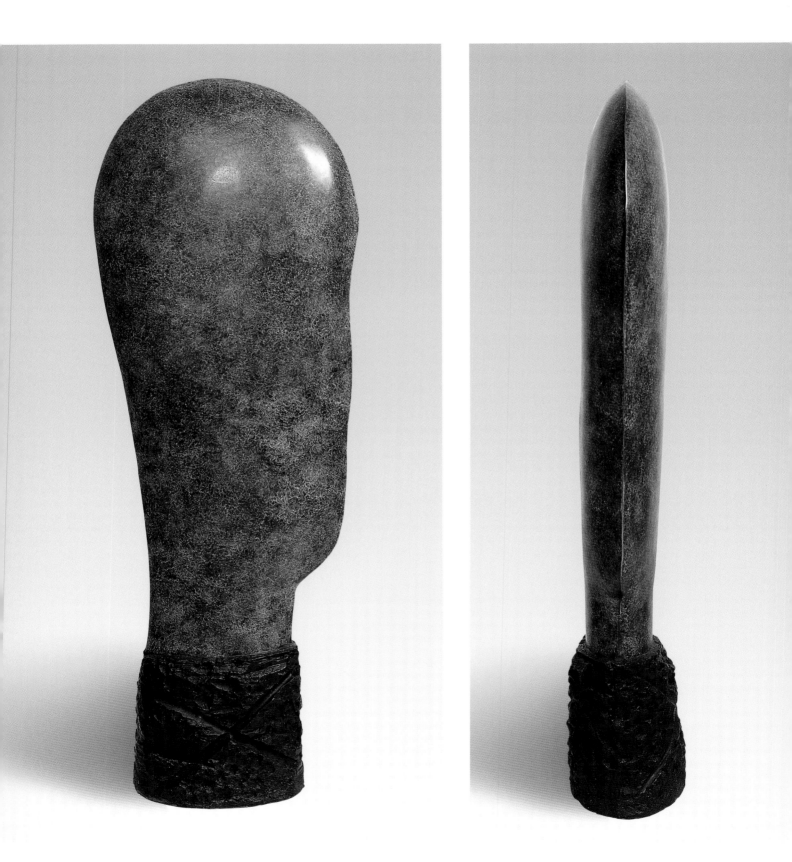

## References

Kapur, Geeta. "The Artist as Bohemian." *Art India*, V, II, February (2000).

Karode, Roobina. "Meandering in Free Zones" from *Living on the Edge*. New Delhi: Gallery Art Inc, 1998. I gratefully acknowledge the use of a quote from the artist as this essay's title.

Paz, Octavio. *Group 1890 Catalogue* (1963).

Singh, Shanta Serbjeet. *Himmat Shah – A Profile. Art Heritage Catalogue* (1982).

Sheikh, Nilima. *A Post-Independence Initiative Contemporary Art in Baroda*. New Delhi: Tulika, 1997, p 59.

Shukla, Prayag. "The Sculptor as Poet". *Art Heritage Catalogue* (1989–90).

Sivaramamurti, C. *South Indian Bronzes*. New Delhi: Lalit Kala Akademi, 1981, p 14.

Untitled essay. *Krishen Khanna Art Heritage Catalogue* (1983).

**Bronze, 52 x 10", Edition of 5**

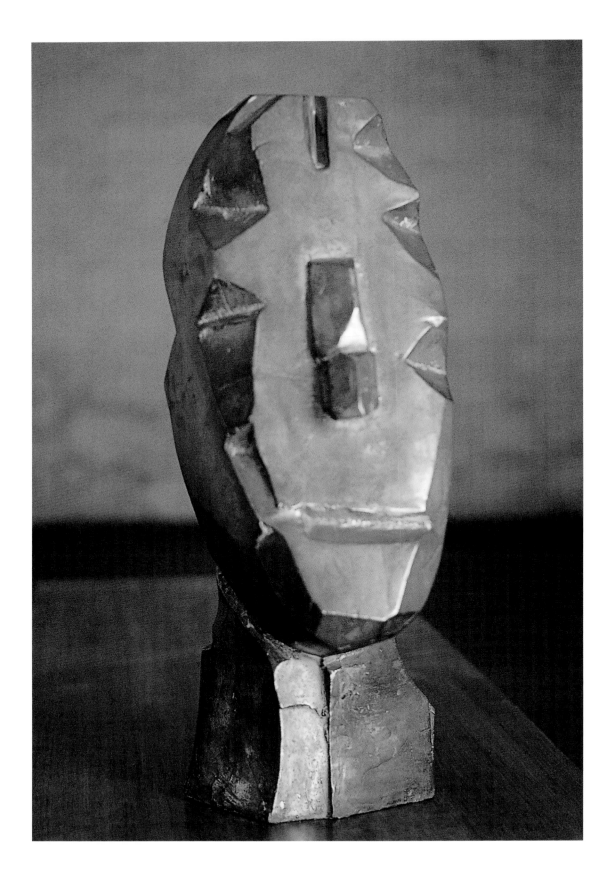

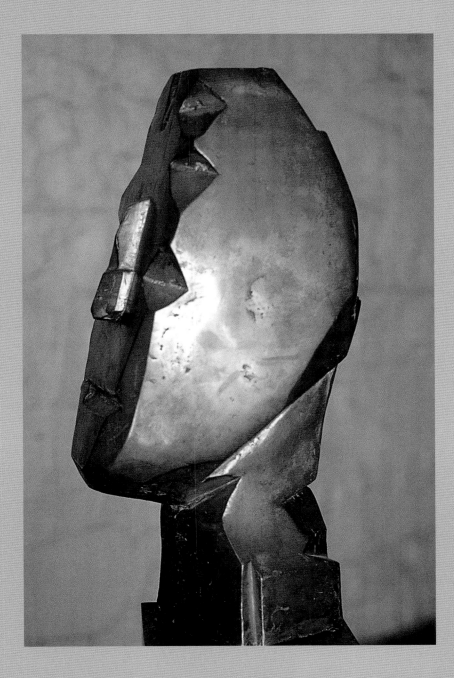

Bronze, 22 x 10"

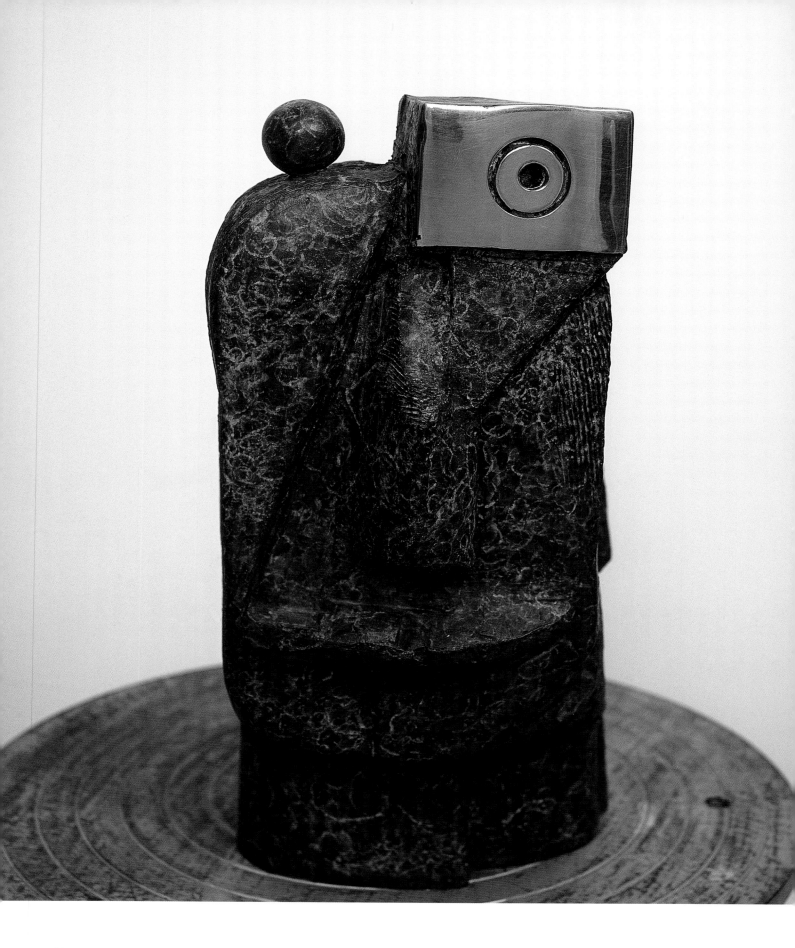

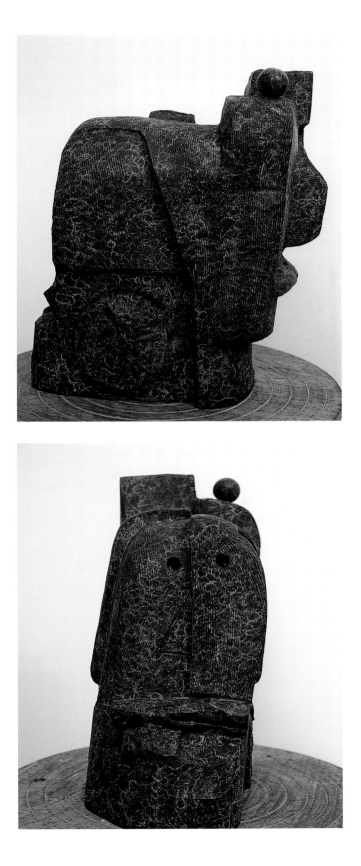

Bronze, 10.5 x 7.5", Edition of 5

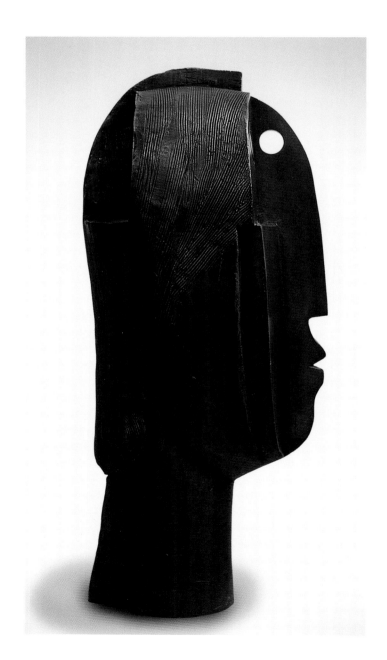

Bronze, 19.5 x 9", Edition of 5

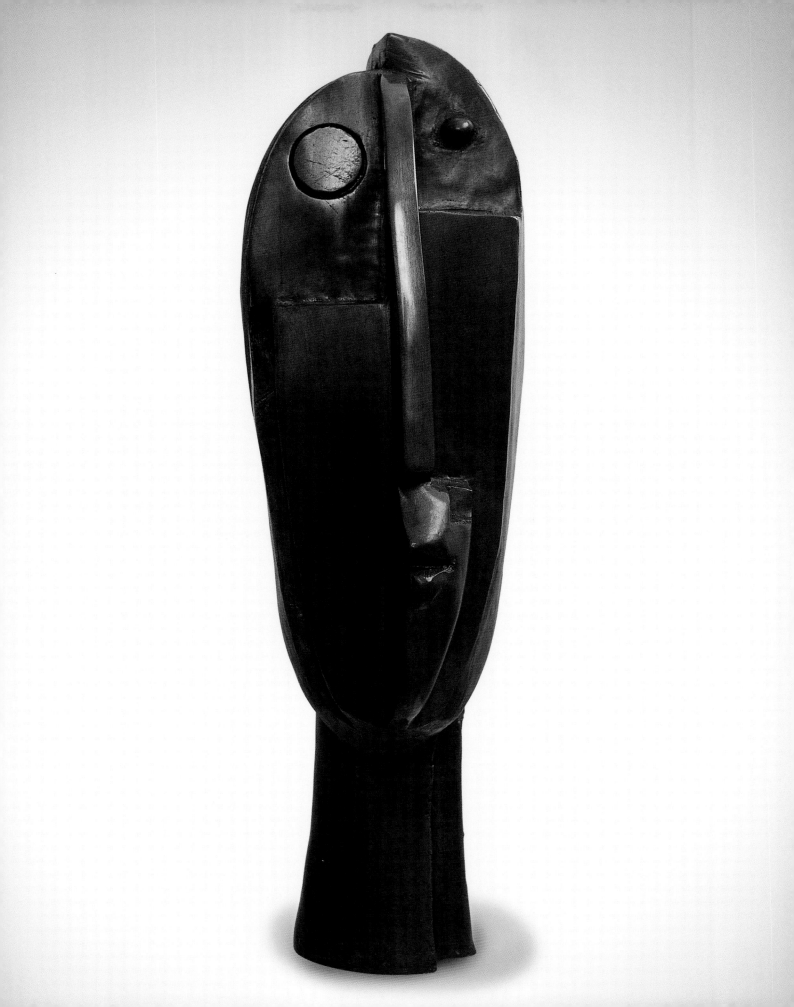

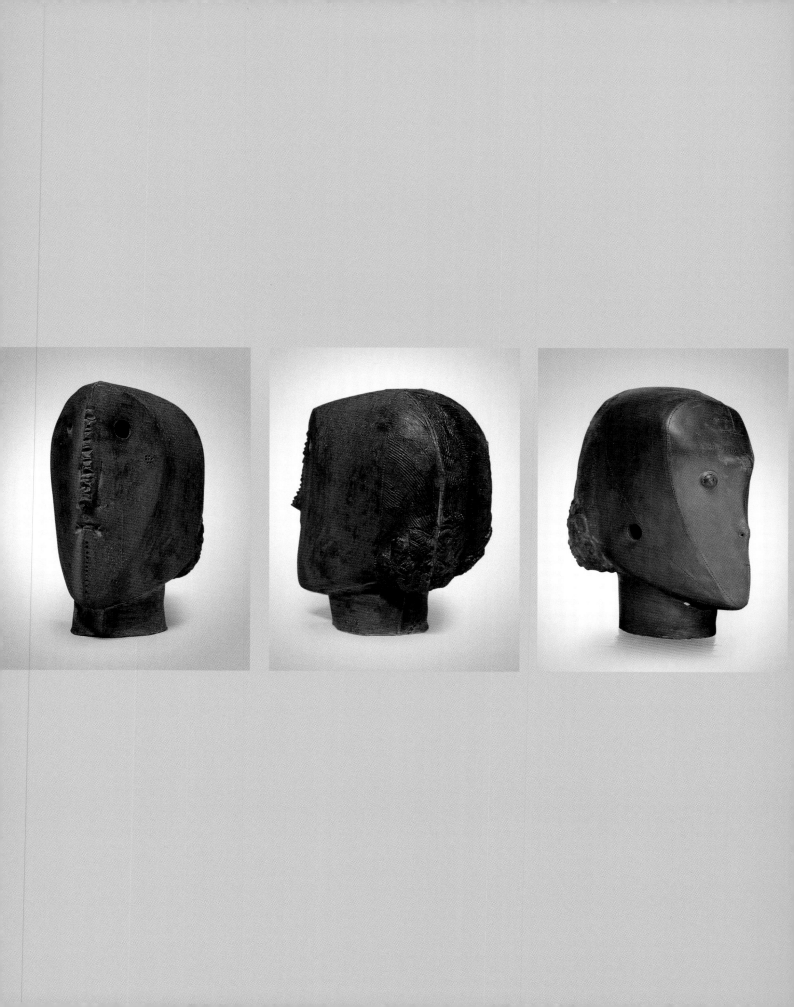

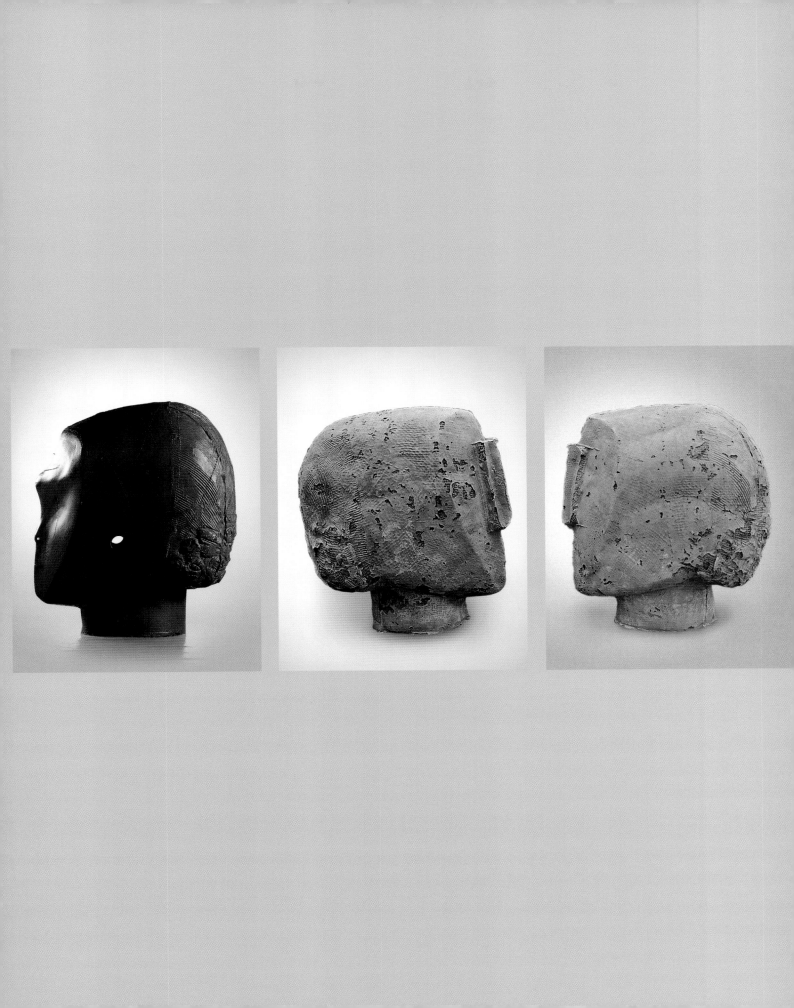

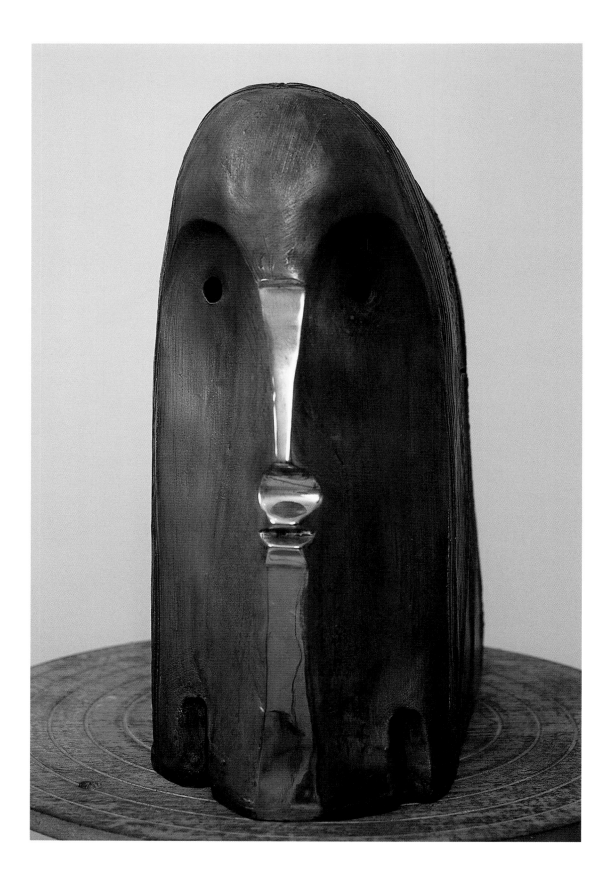

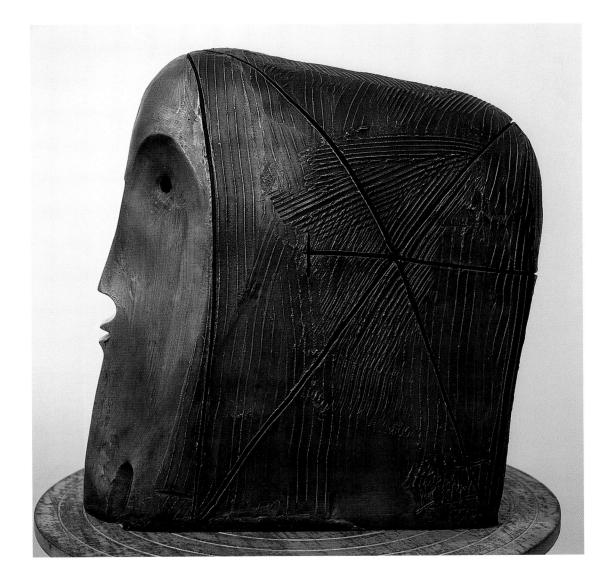

Bronze, 10.5 x 9.5", Edition of 5

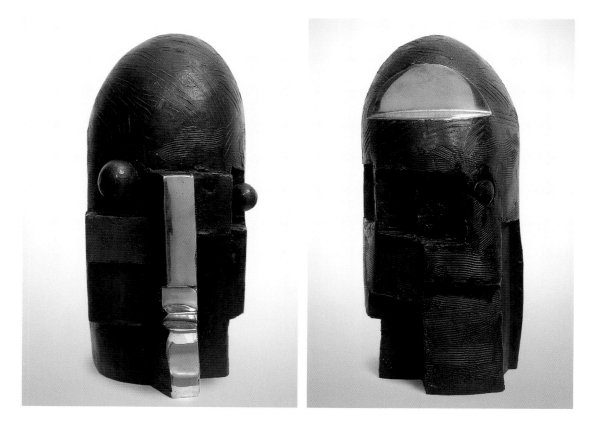

Bronze, 12.5 x 8", Edition of 5

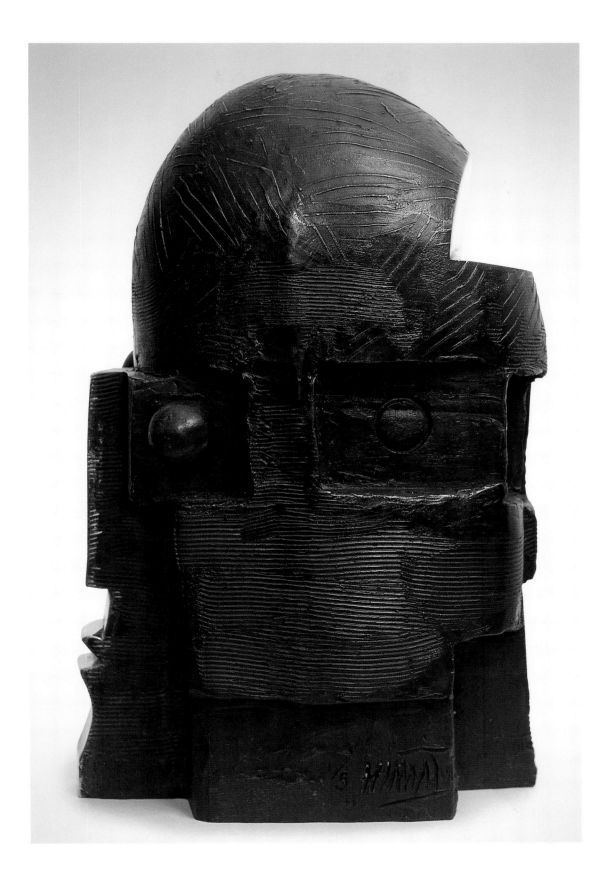

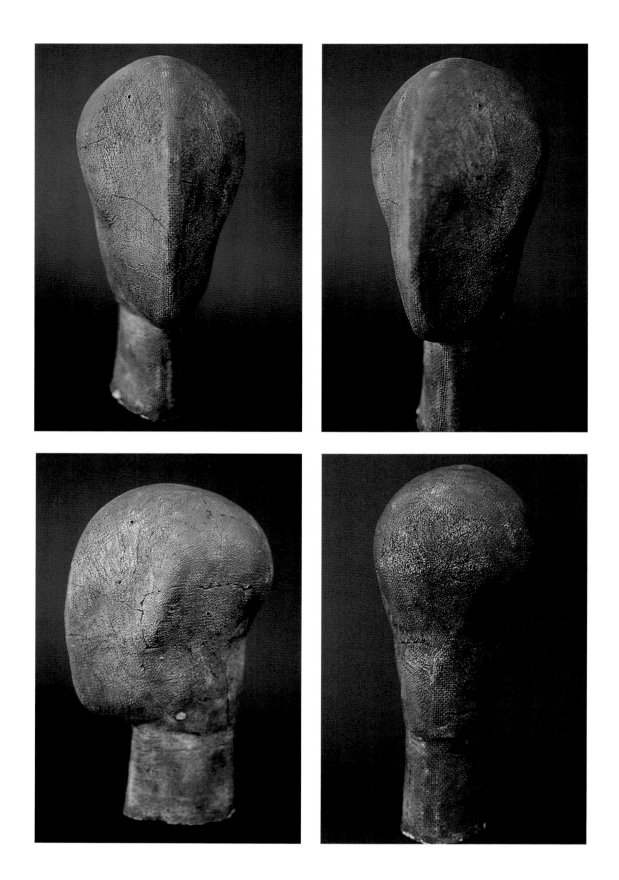

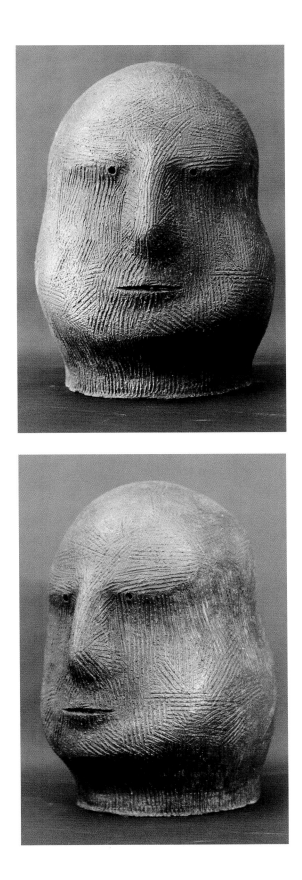

Bronze, 26 x 7.5", Edition of 5

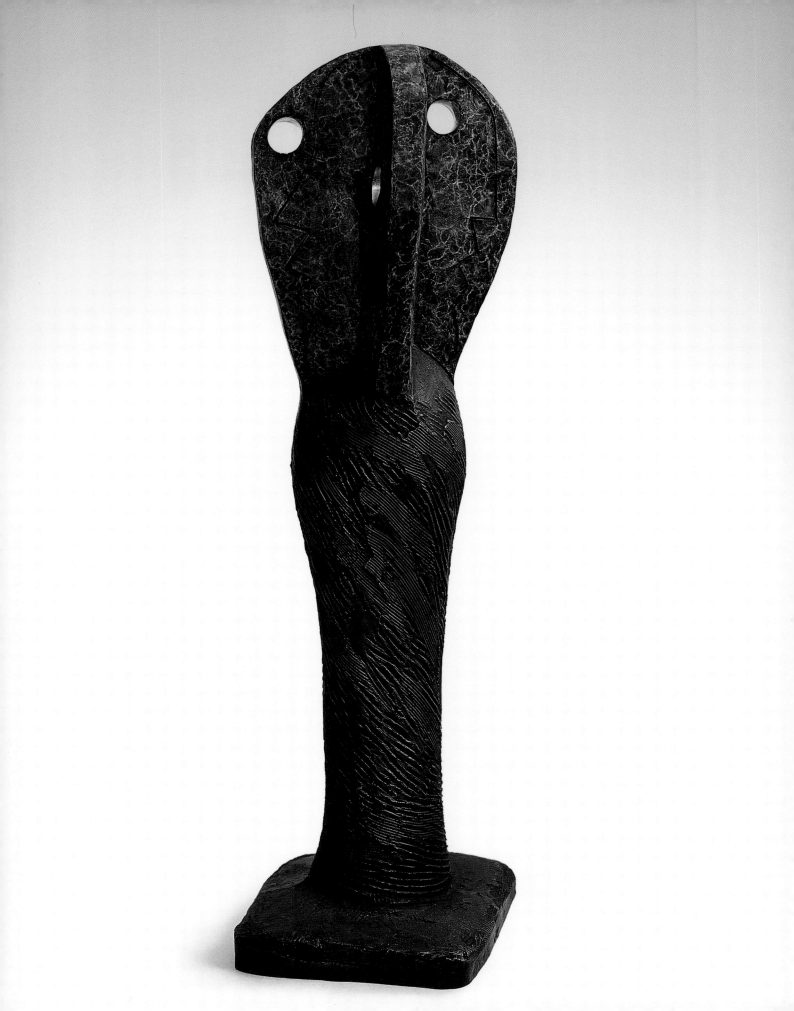

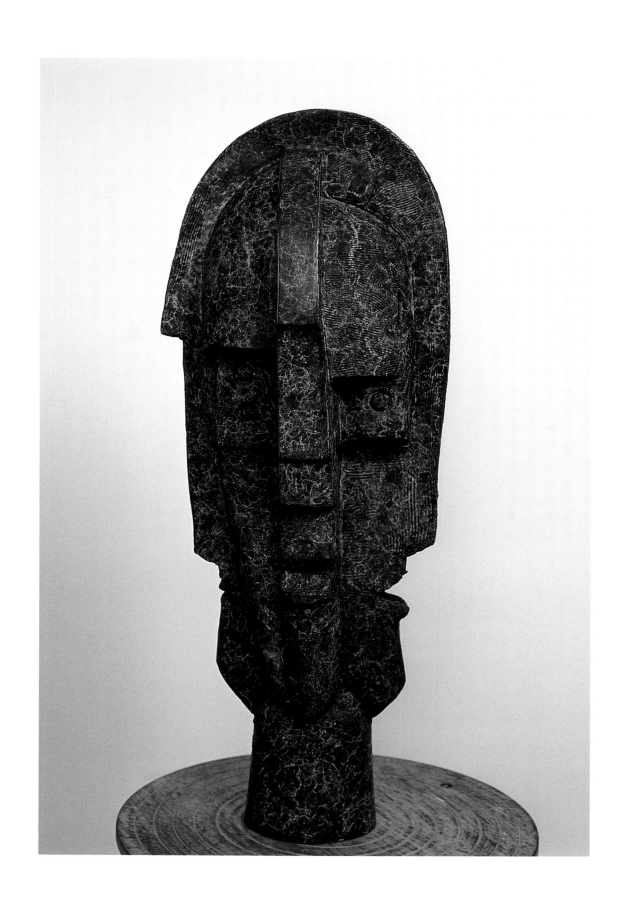

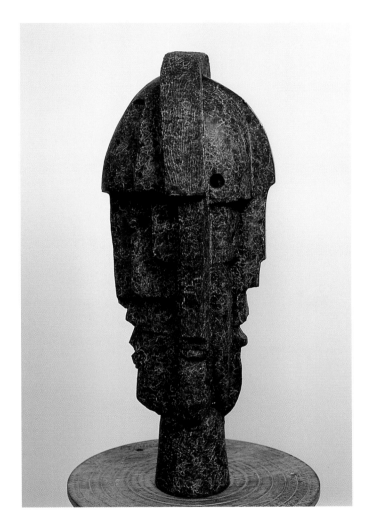

Bronze, 19.5 x 9", Edition of 5

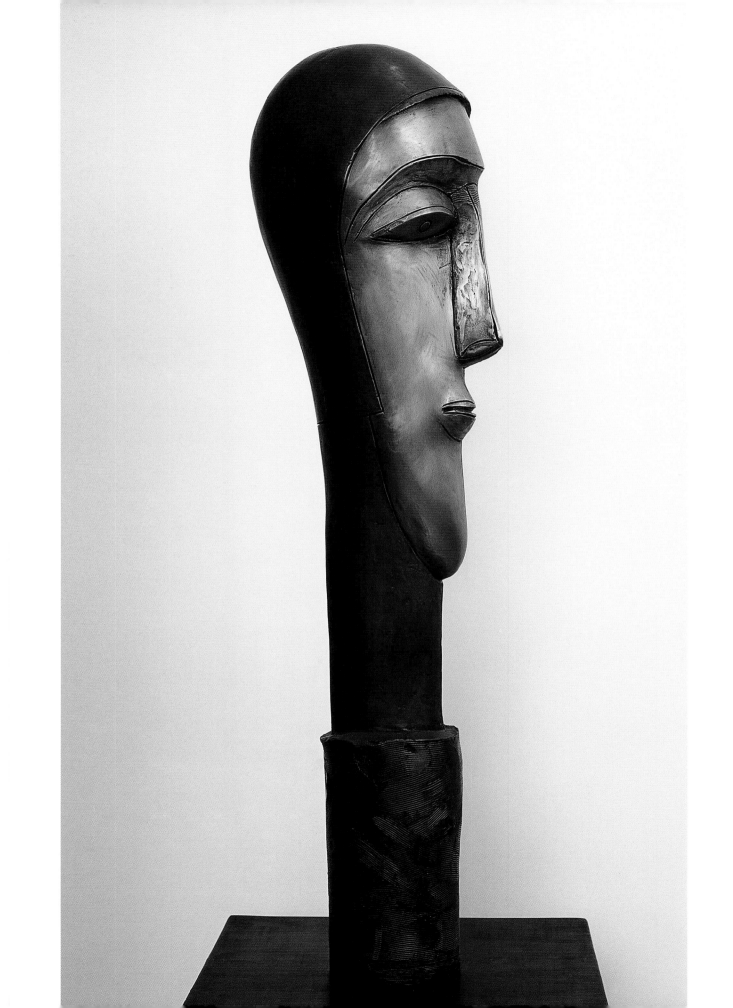

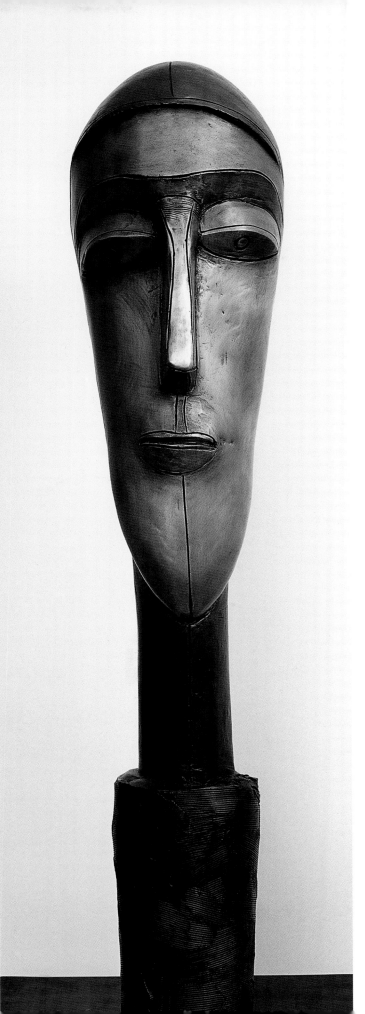

Bronze, 36.5 x 8", *Meditation*, Edition of 5

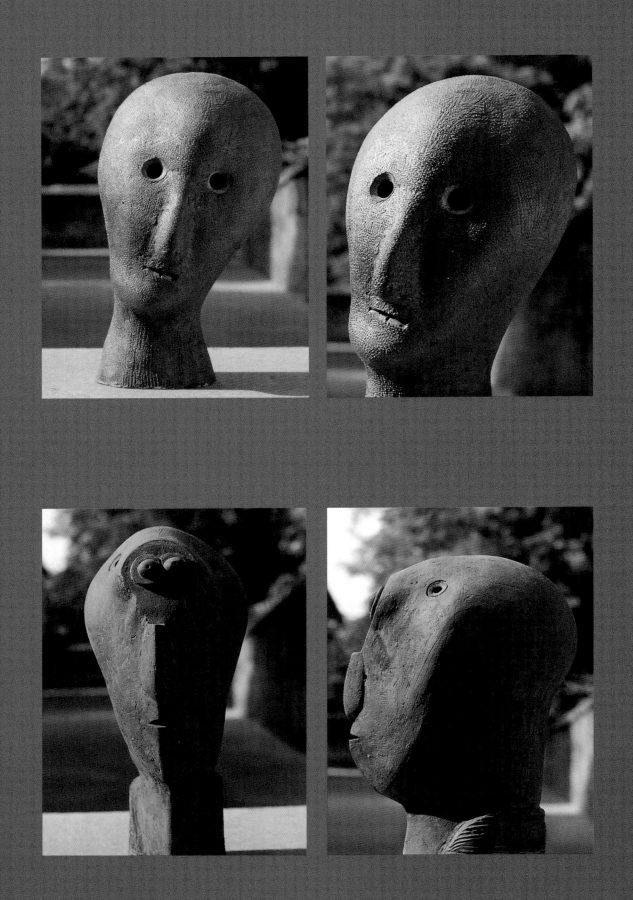

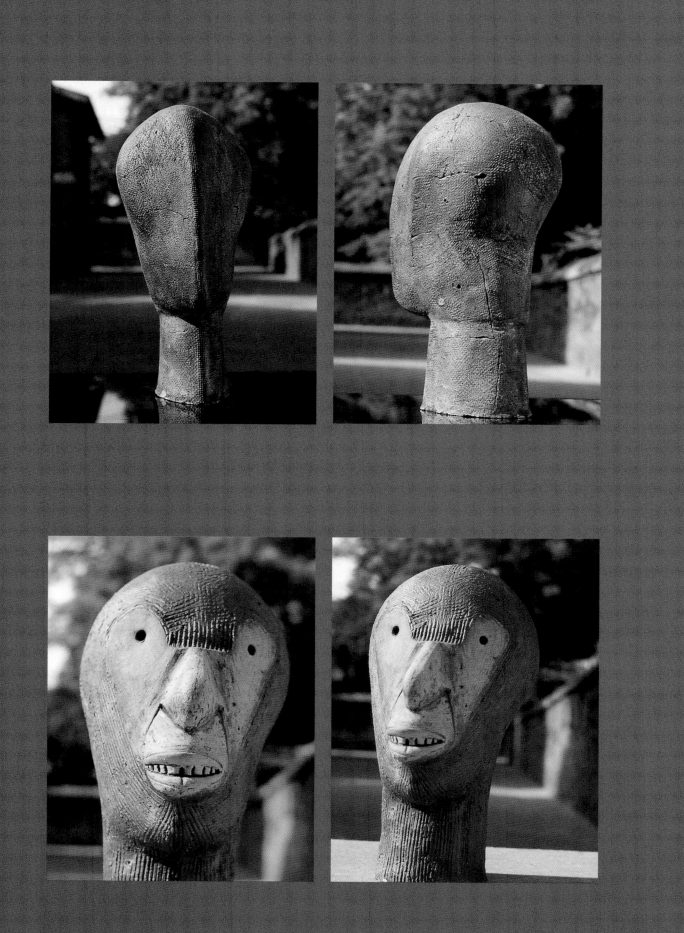

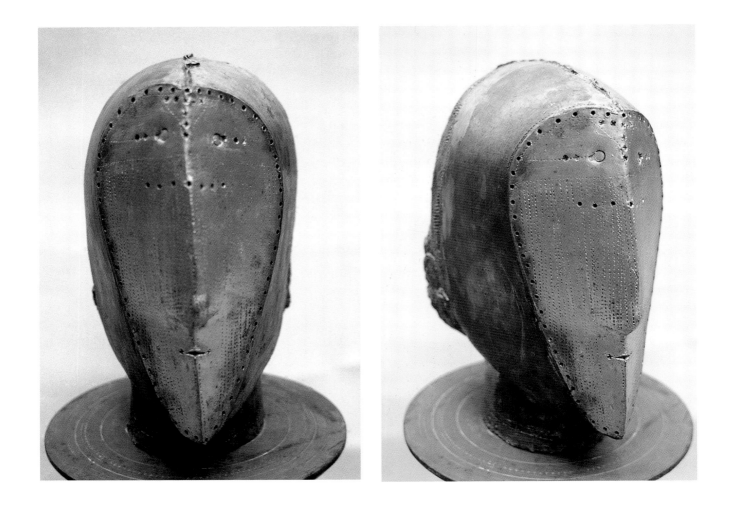

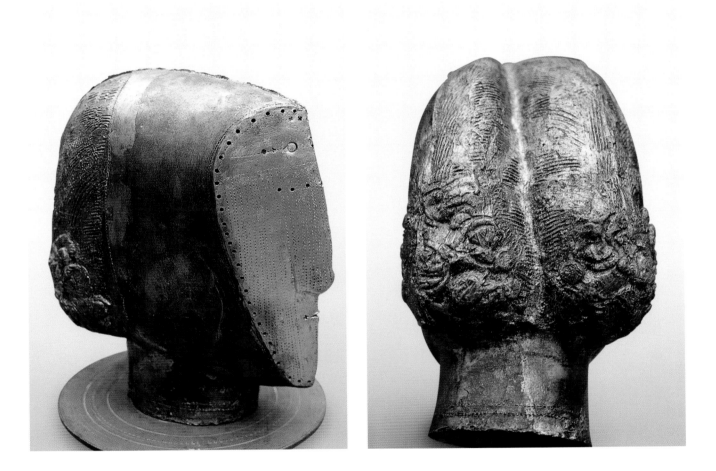

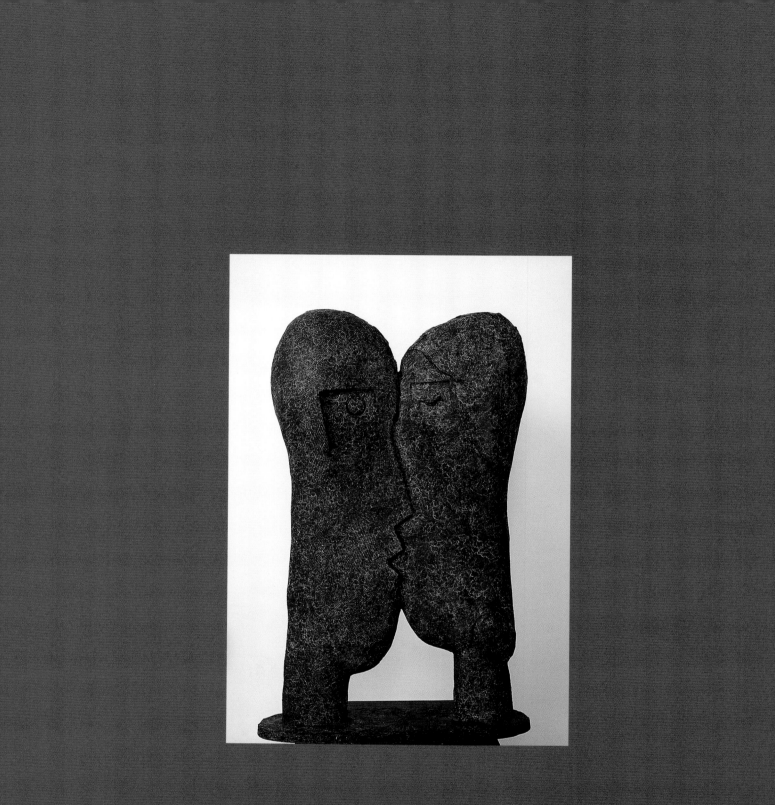

Bronze, 33.5 x 20.5", *Kiss*, Edition of 5

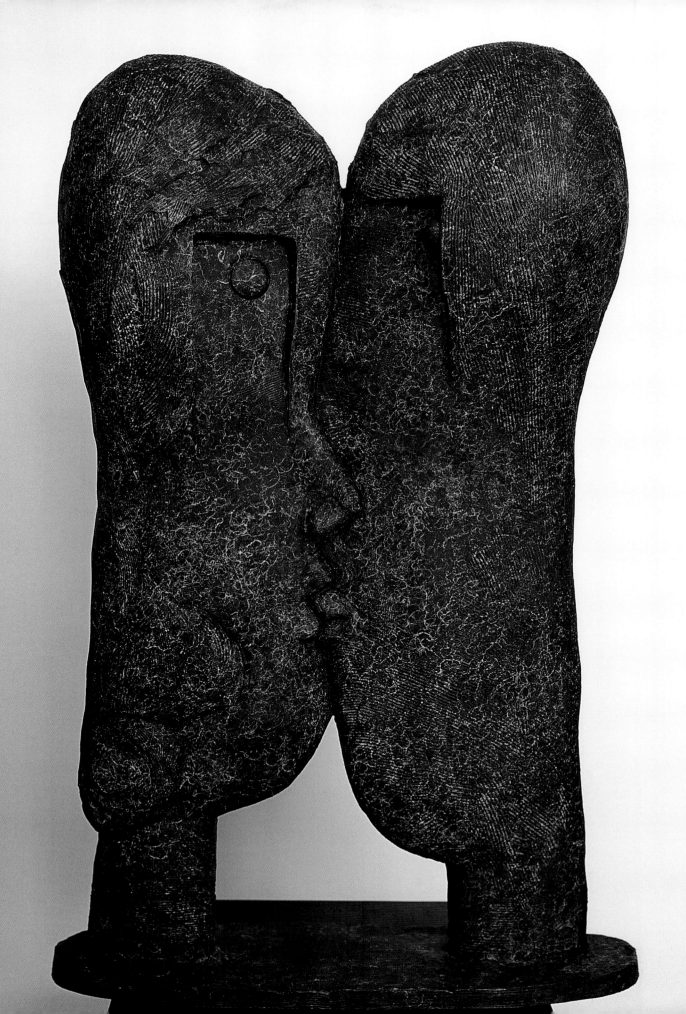

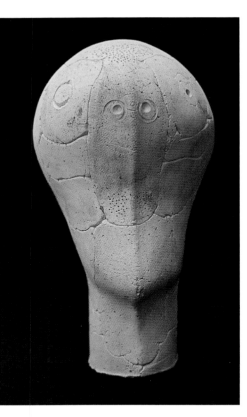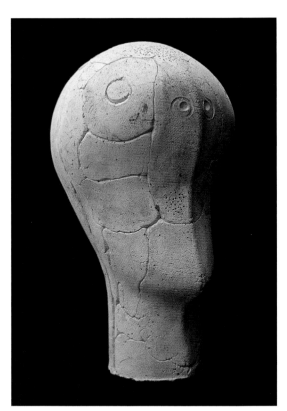

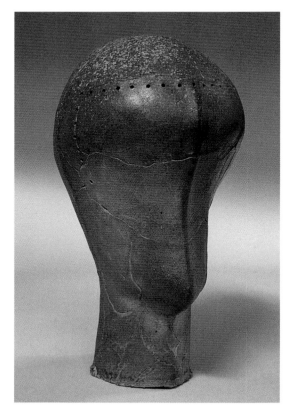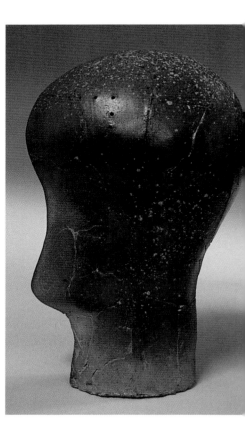

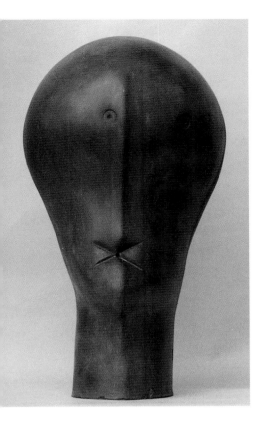

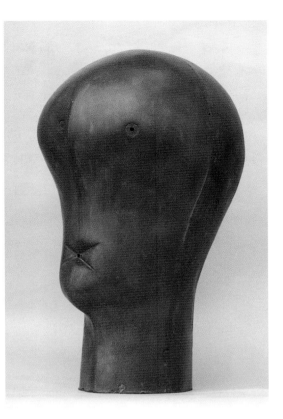

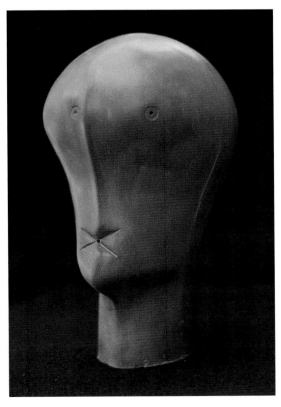

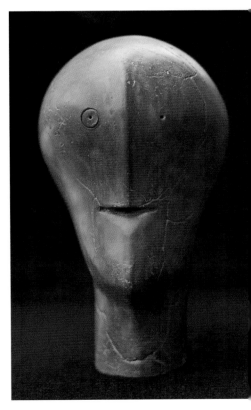

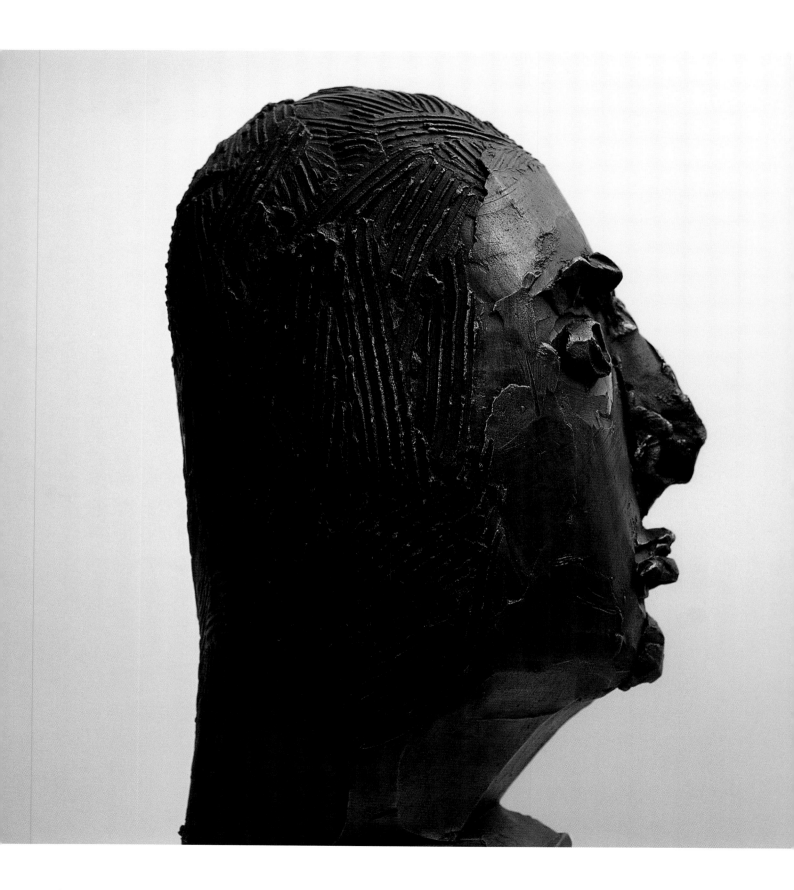

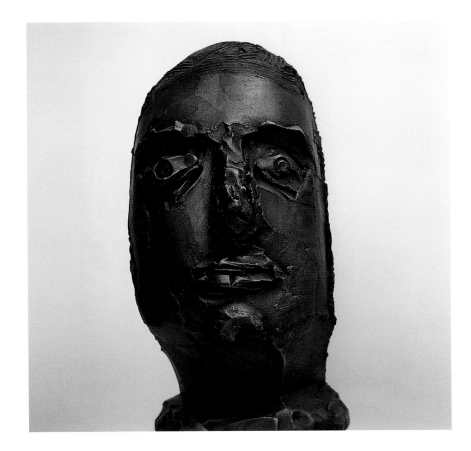

Bronze, 14 x 7.5", Edition of 5

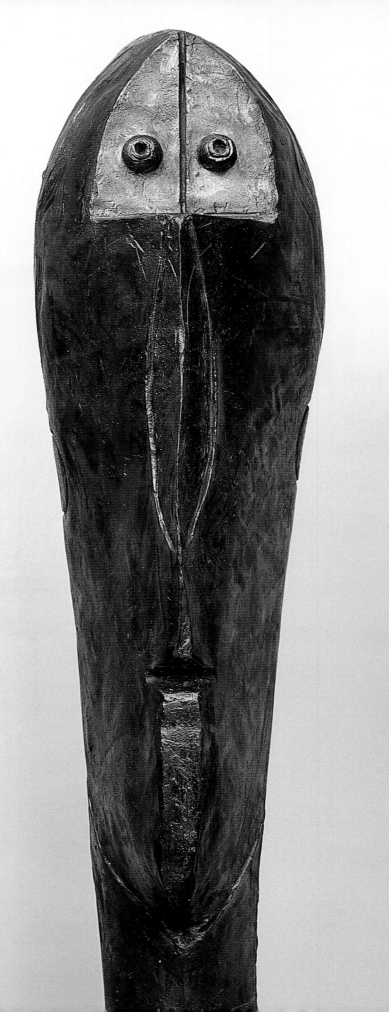

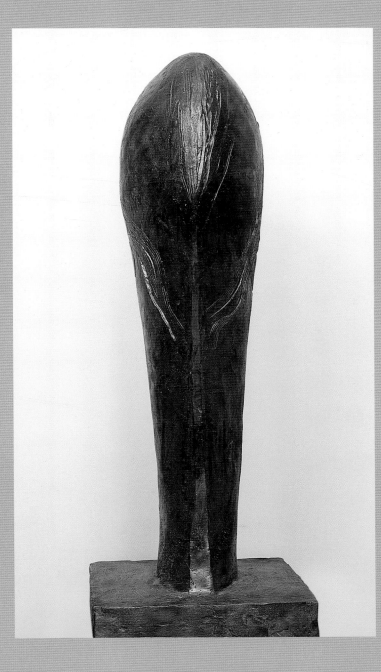

Bronze, 36 x 12", Edition of 5

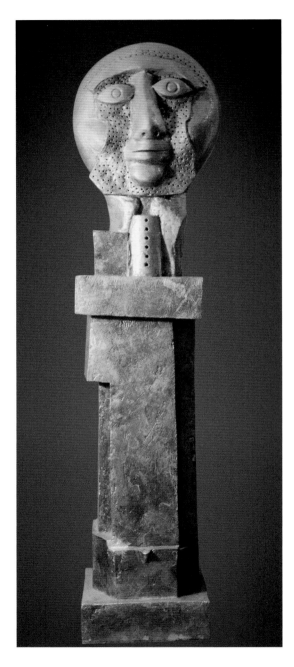

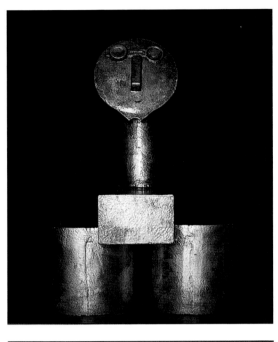

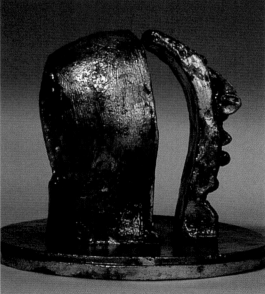

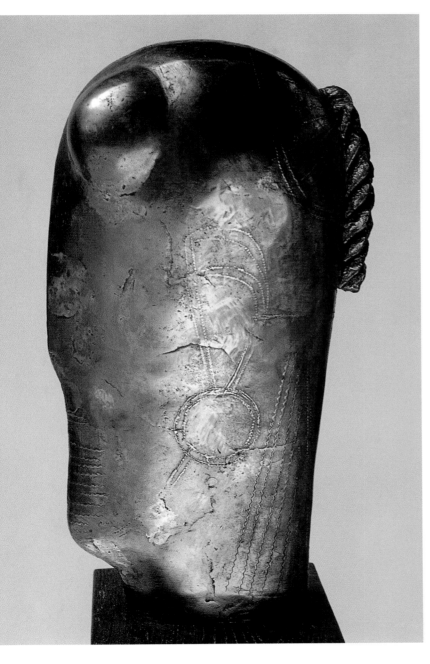

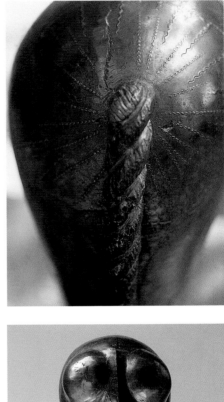

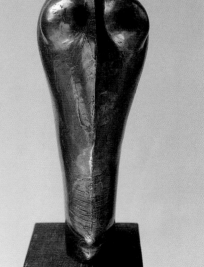

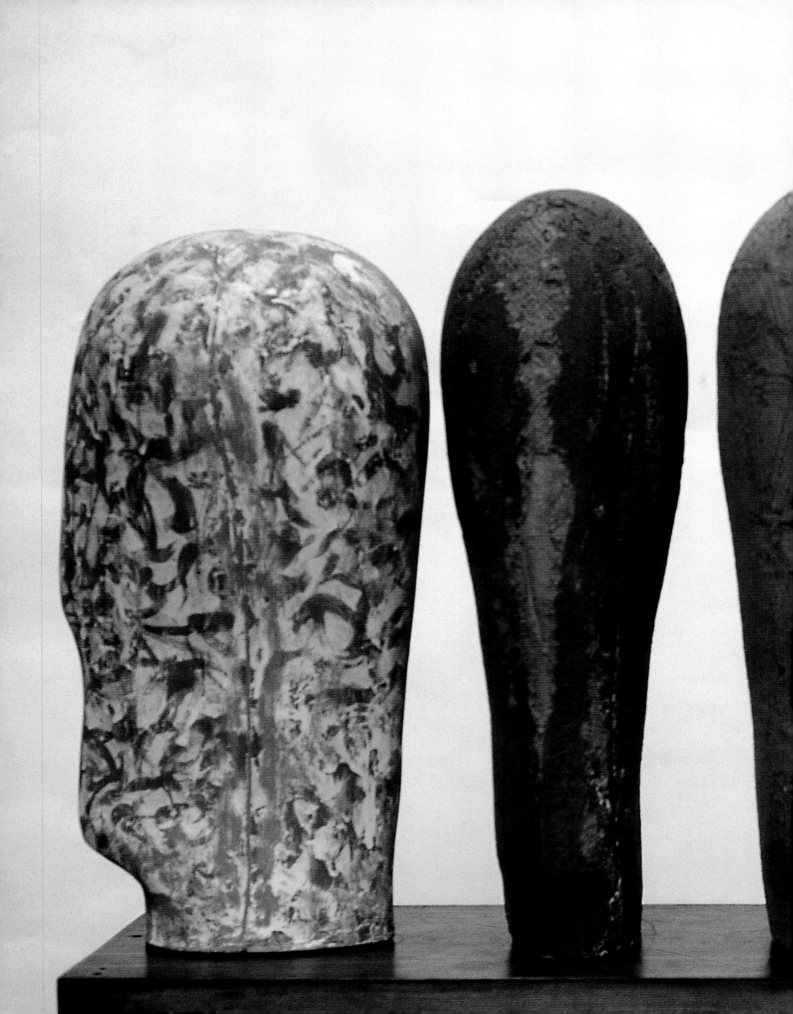

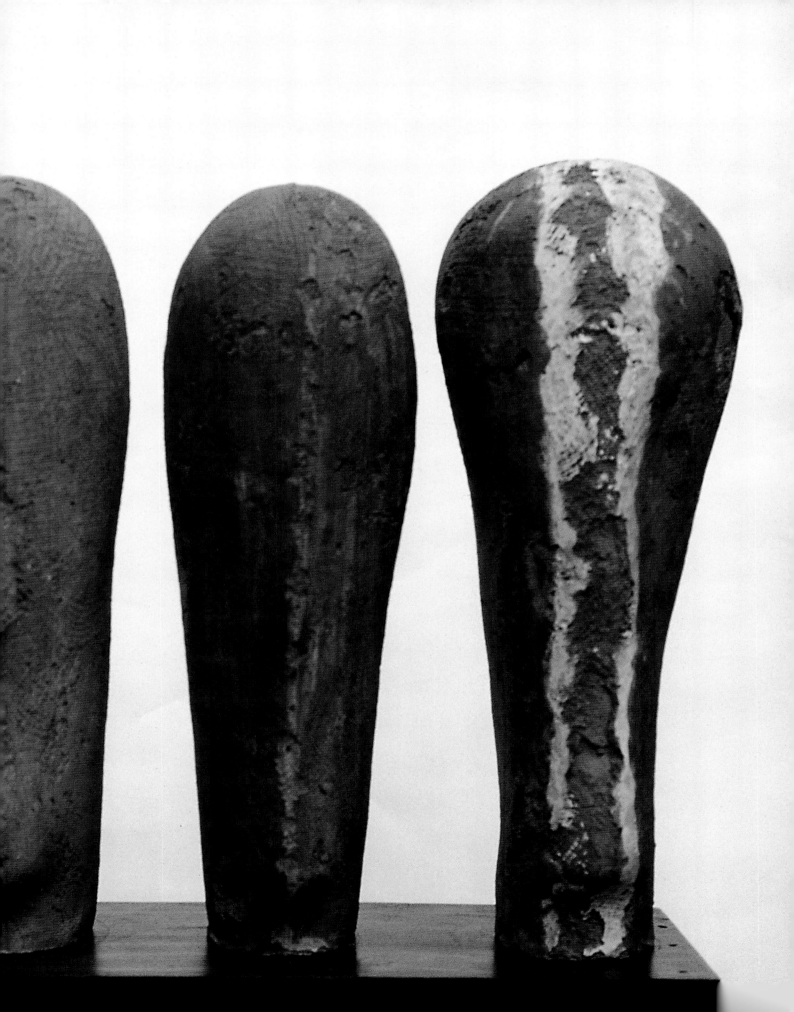

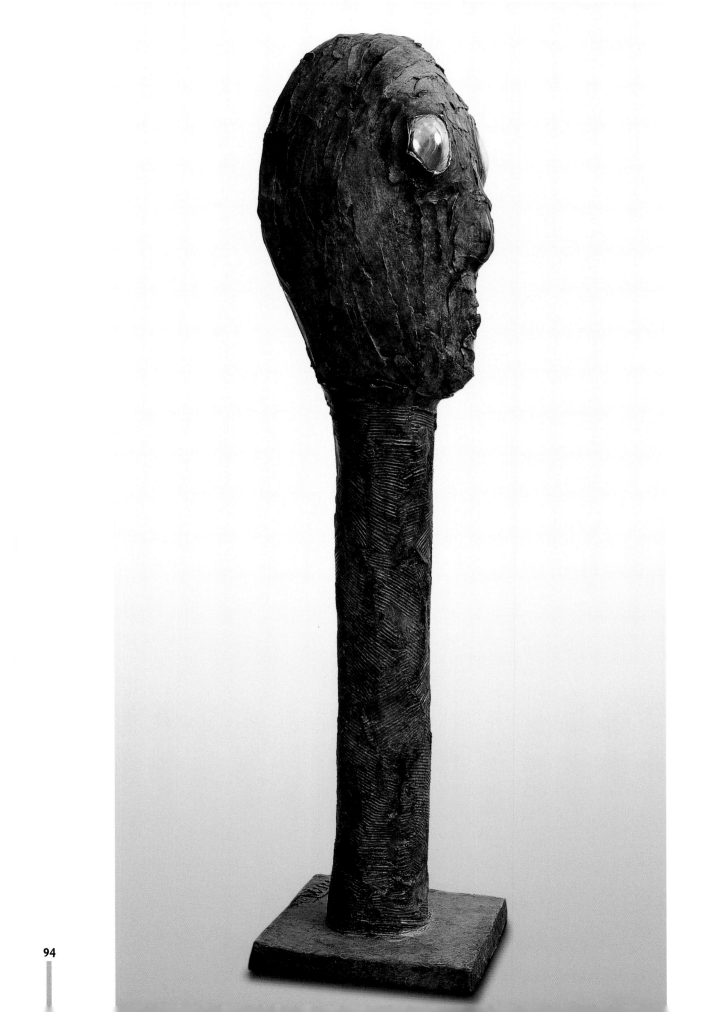

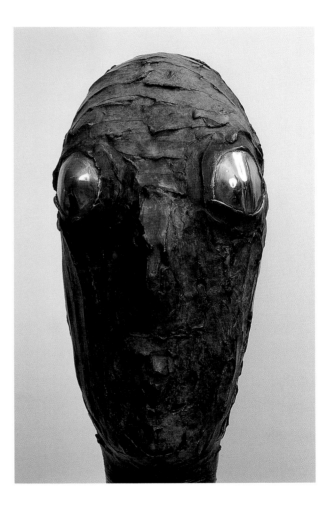

Bronze, 26 x 7.5", *Evil Breaker*, Edition of 5

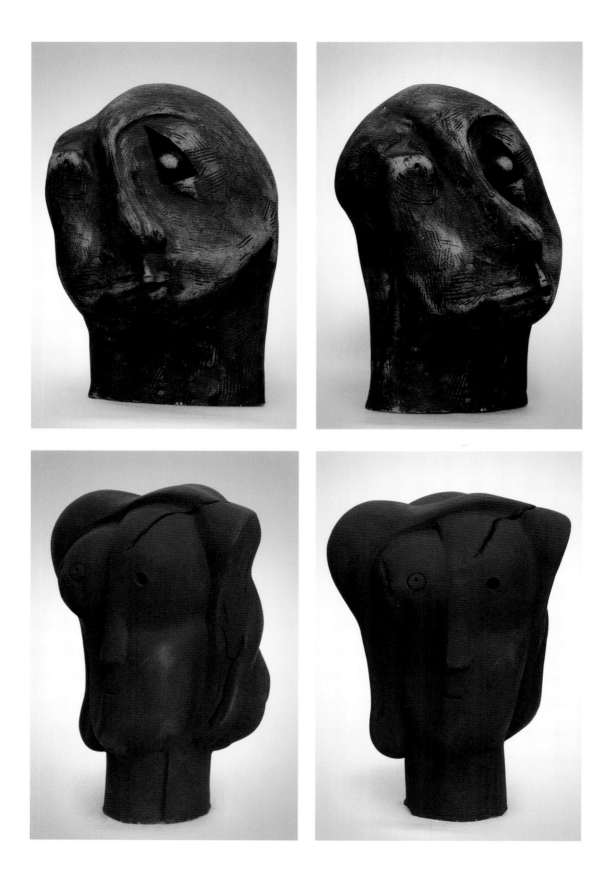

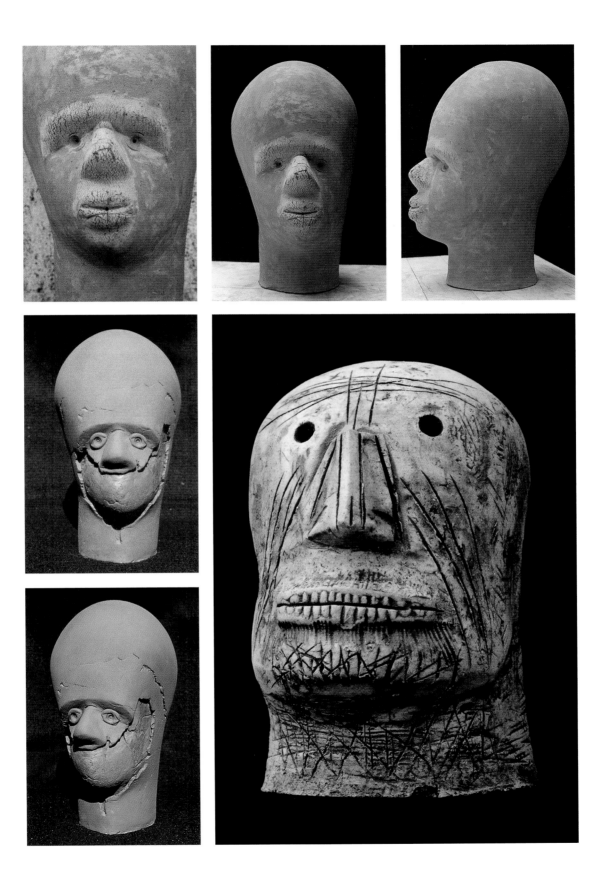

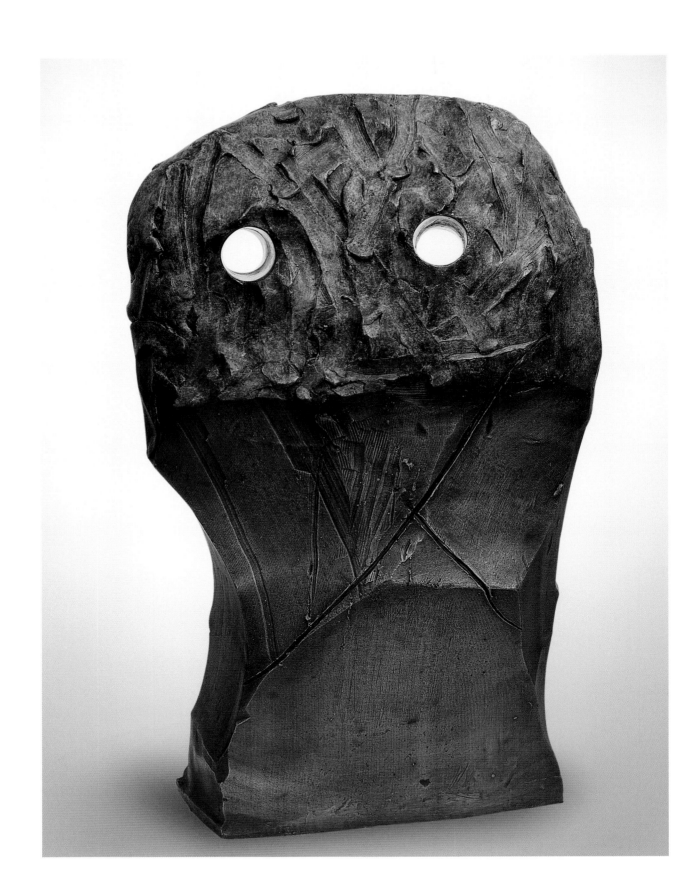

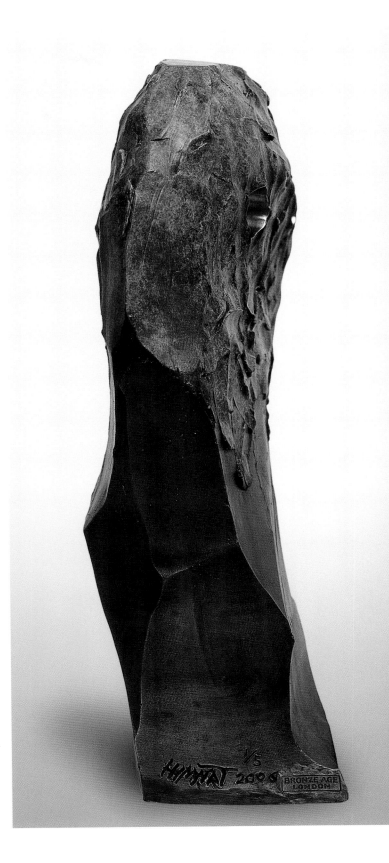

Bronze, 15 x 9", Edition of 5

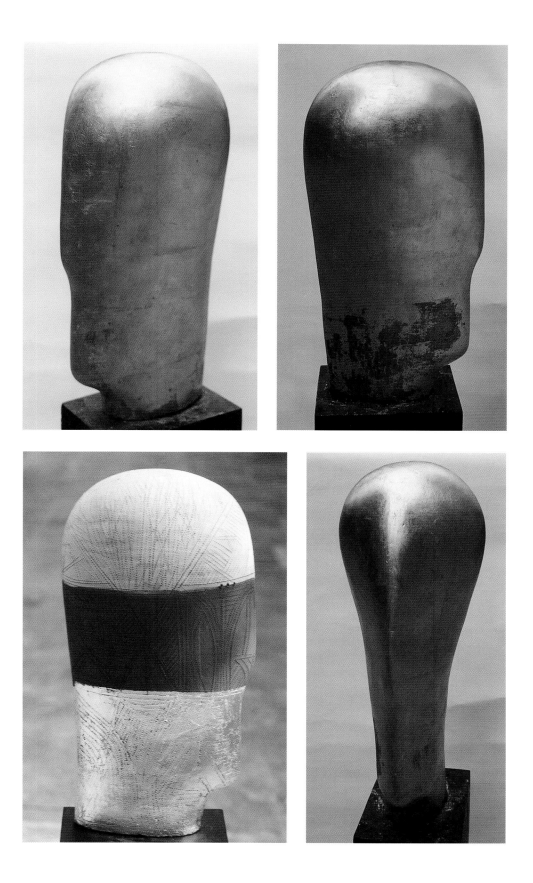

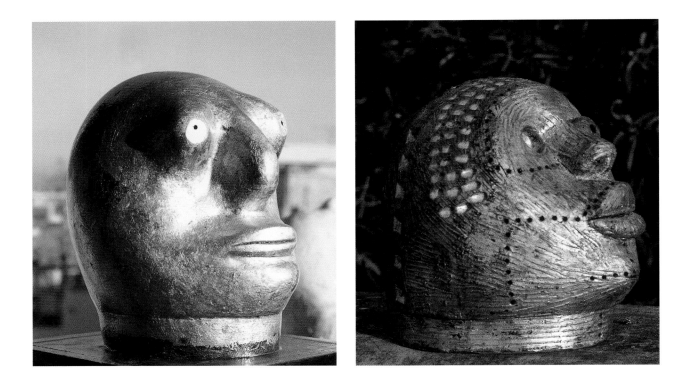

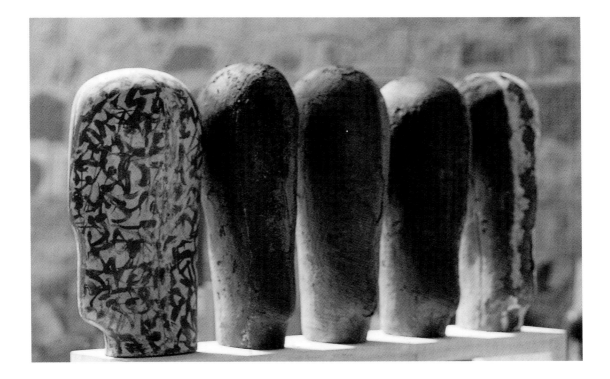

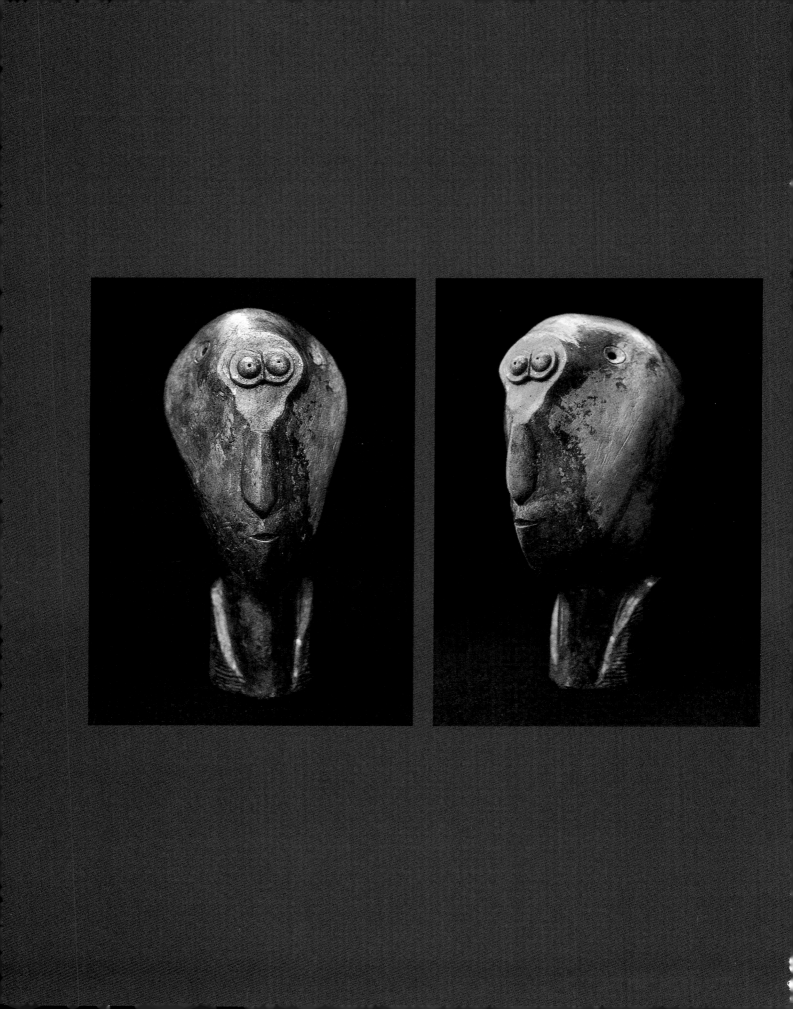

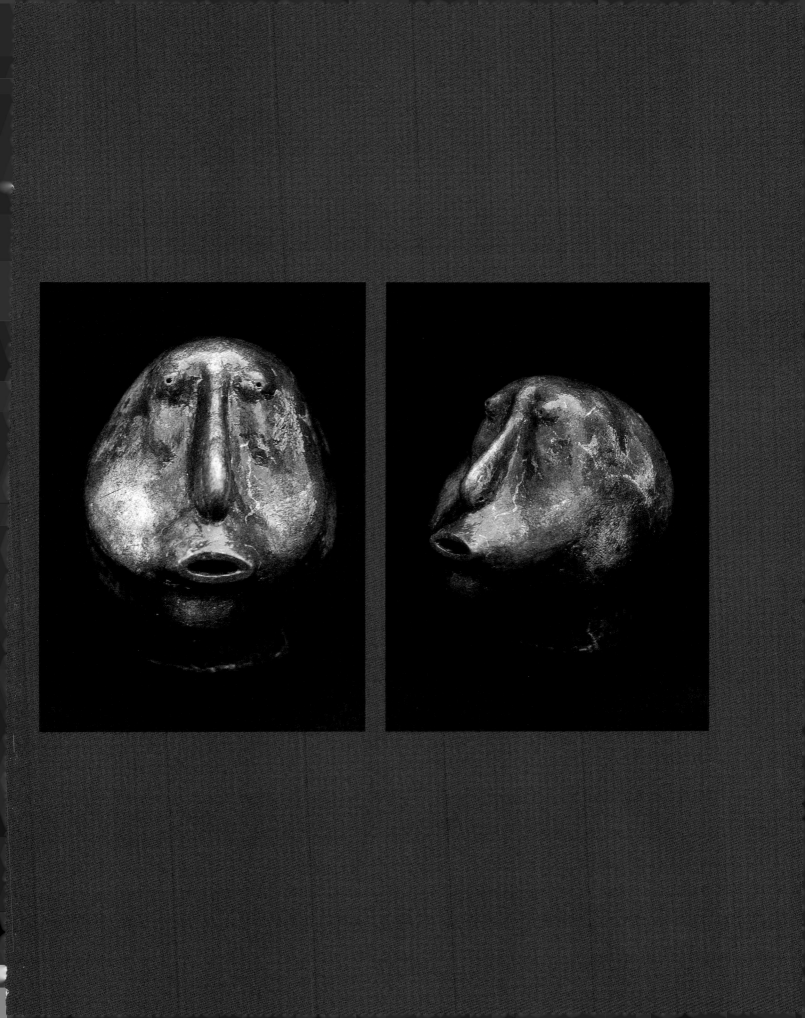

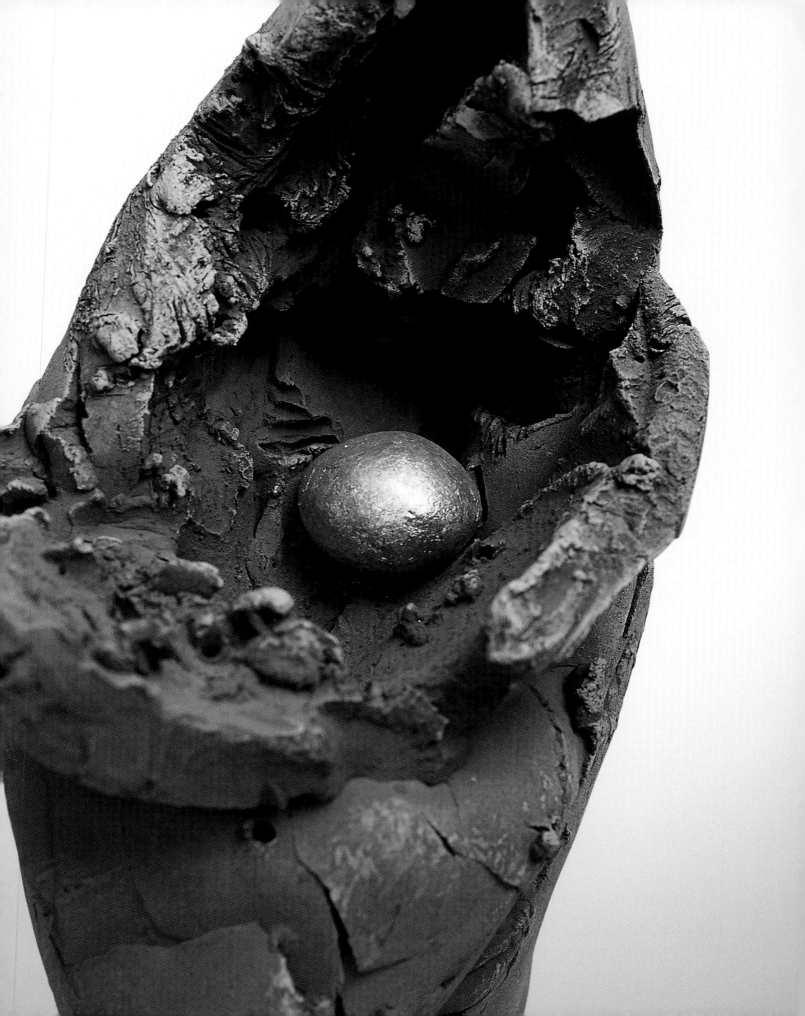

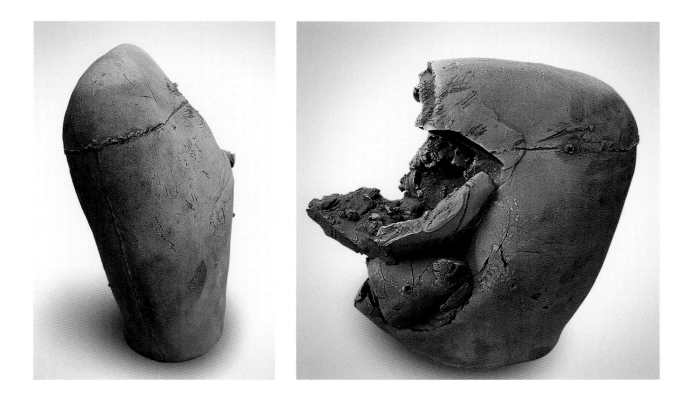

Terracotta, 11 x 4.5 x 11"

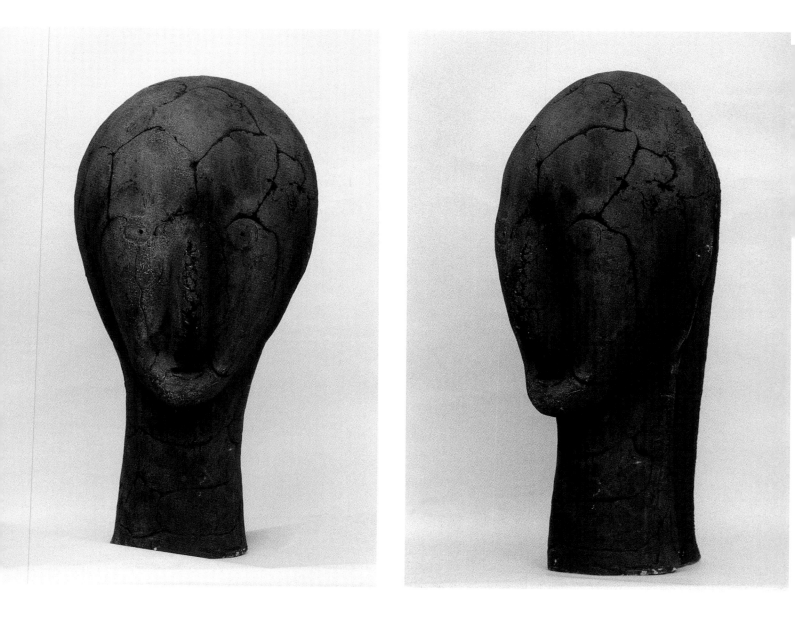

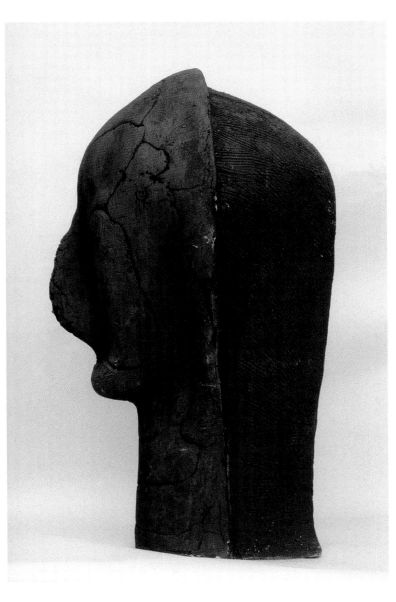

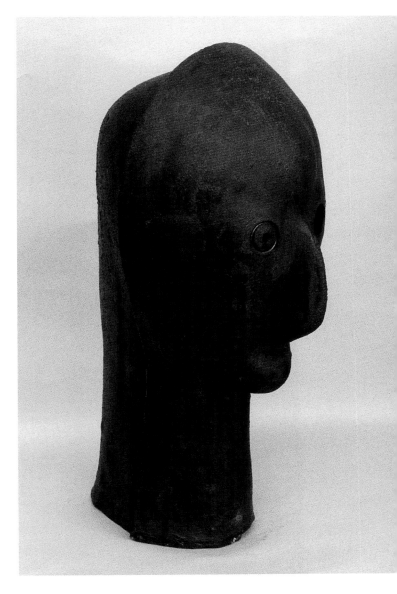

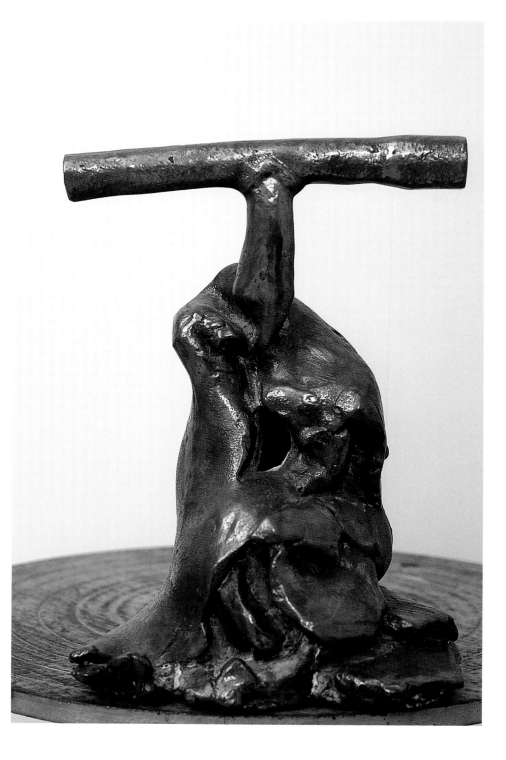

Bronze, 8 x 6", Edition of 7

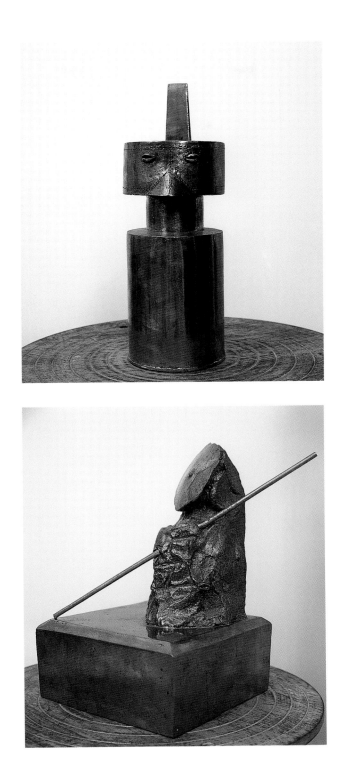

Above: **Bronze, 10 x 5.5", Edition of 5**
Below: **Bronze, 9 x 6",** *Man on Moon*, **Edition of 9**

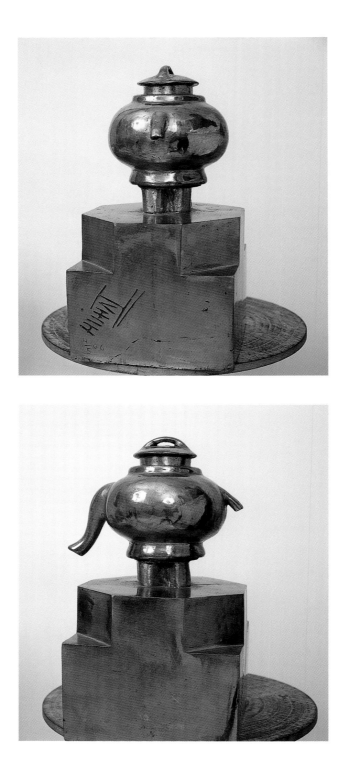

Bronze, 11.5 x 7", Edition of 5

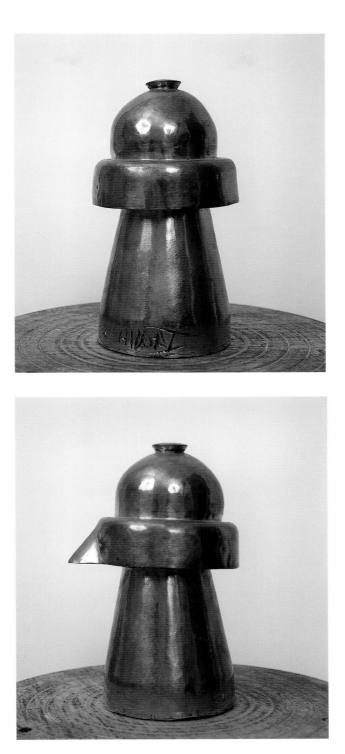

Bronze, 8 x 5.5", Edition of 5

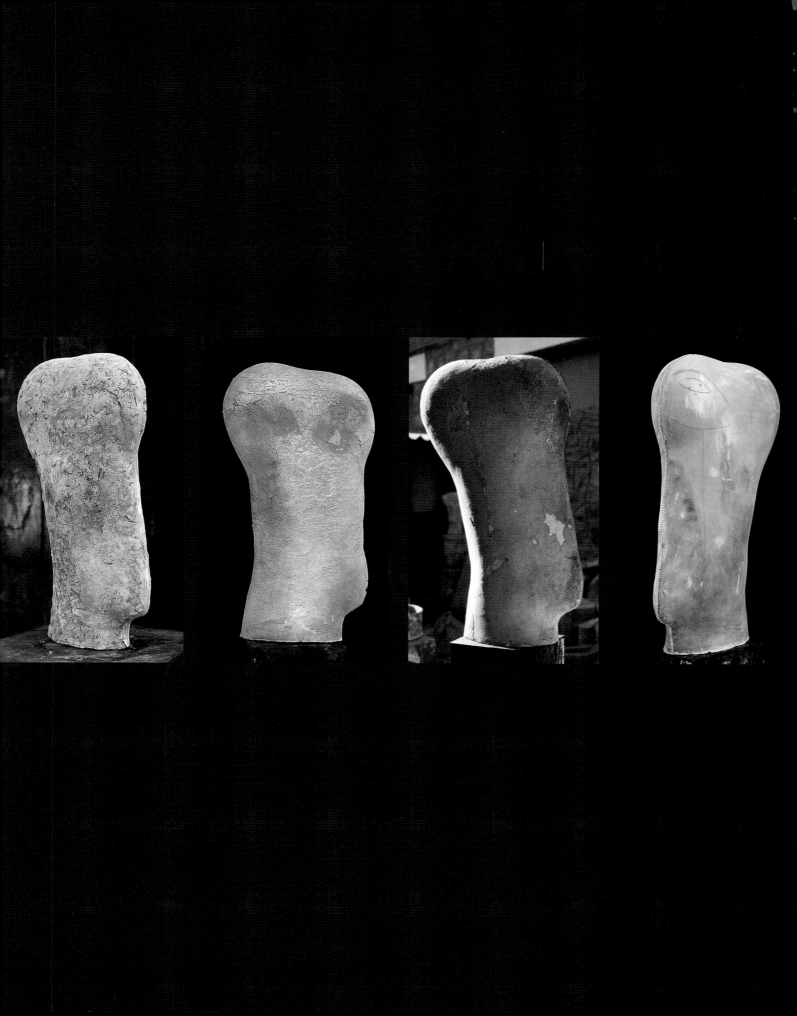

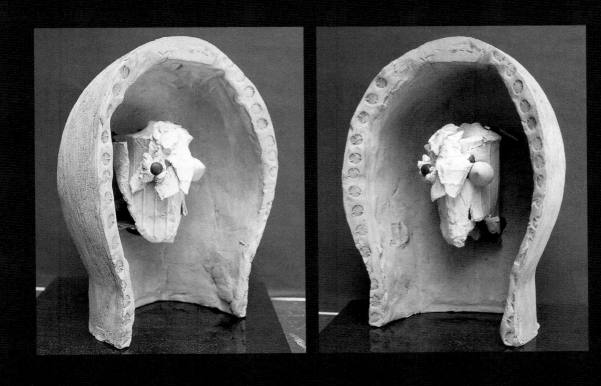

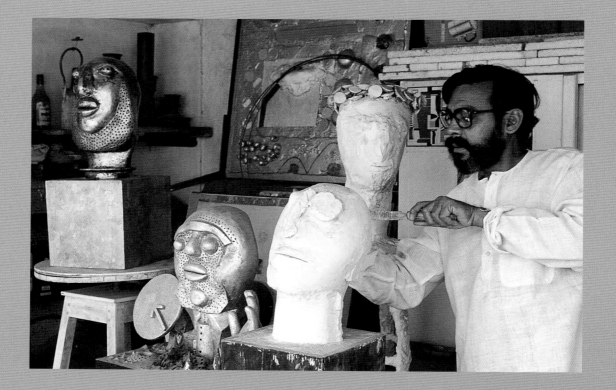

# CHRONOLOGY

**1962**
Born in Lothal, Gujarat.
**1968–69**
Designed three murals for St. Xavier's
School, Ahmedabad.
Founder member of Group 1890,
Bhavnagar.
Lives and works in Jaipur.

## EDUCATION
**1952**
Studied under Shri Jagubhai Shah,
Bhavnagar.
**1953**
Drawing Teacher's Course, J.J. School of
Art, Bombay.
**1955**
Studied at Maharaja Sayajirao University,
Baroda.
**1956–61**
Worked under Professor N.S. Bendre,
Faculty of Fine Arts, M.S. University,
Baroda.
**1966–67**
Studied under S.W. Hayter and
Krishna Reddy, Atelier 17, Paris.

## SOLO EXHIBITIONS
**1964**
Exhibition of drawings, Triveni Gallery,
New Delhi.
**1964**
Kunika Chemould Art Centre, New Delhi.
**1965**
Art and Print Gallery, Calcutta.
**1965**
Kunika Chemould Art Centre, New Delhi.
**1966**
Gallery Chemould, New Delhi and Bombay.

**1971**
Konark Art Gallery, New Delhi.
**1973**
Max Mueller Bhavan, New Delhi.
**1974**
Indian Institute of Technology, New Delhi.
**1976**
Madhya Pradesh Kala Parishad Gallery,
Bhopal.
**1979**
First sculpture exhibition, Dhoomimal Art
Gallery, New Delhi.
**1980**
Drawings, Visual Art Centre, Ahmedabad.
**1982**
Drawings, Garhi, Lalit Kala Akademi,
New Delhi.
**1983**
Sculpture, Art Heritage, New Delhi.
**1994**
Sculpture, Sakshi Gallery, Bombay.
**1997**
*A Real Contemporary Vision*, drawings,
Shahjahan Art Gallery, New Delhi.
**1997**
*Yellow Deity*, Museum of Contemporary
Art, Ludwig Museum, Budapest.
**1998**
Drawings, Art Inc. Gallery, New Delhi.
**1999**
*Notable Exceptions*, I'm Gallery, New Delhi.
**2000**
Art Heritage Gallery, New Delhi.
**2000**
Shridharani Gallery, New Delhi.
**2002**
Sculpture, Art Heritage, New Delhi.
**2005**
Anant Art Gallery, New Delhi.

## WORKSHOPS

**1970**

Printmaking workshop, Smithsonian Institute, U.S.I.S., New Delhi.

**1981**

Ceramic Camp, Garhi, organized by Lalit Kala Akademi, New Delhi.

## COLLECTIONS

Ebrahim Alkazi and Art Heritage, New Delhi; Lalit Kala Akademi, New Delhi and National Gallery of Modern Art, New Delhi among others.

## GROUP EXHIBITIONS

**1957–58**

Baroda Group Show, Bombay.

**1960**

National Exhibition, Rabindra Bhavan, Lalit Kala Akademi, New Delhi.

**1962**

Progressive Painters Group Exhibition, Ahmedabad.

**1963**

Group 1890 Show, inaugurated by the then Prime Minister of India, Pandit Jawaharlal Nehru, New Delhi.

**1967**

Biennale de Paris.

**1967–68**

Progressive Painters Group Exhibition, Ahmedabad.

**1967–68**

*Five Contemporaries*, Kunika Chemould Art Centre, New Delhi.

**1968**

Triennale, National Exhibition of Art, Lalit Kala Akademi.

**1970**

Biennale de Paris.

**1975**

Biennale–13, Middleheim 1975, Antwerpen.

**1977**

*Pictorial Space*, curated by Geeta Kapur, New Delhi.

**1978**

Prints, Garhi, Lalit Kala Akademi, New Delhi.

**1979**

Silver jubilee exhibition of sculpture, Lalit Kala Akademi, New Delhi and Bombay.

**1982**

Represented in inaugural show of Roopankar Museum, Bharat Bhavan, Bhopal.

**1982**

Represented in the Contemporary Art Show, Festival of India, London.

**1989**

*Timeless Art*, organized by *The Times of India*, Bombay.

**1991**

*Nine Indian Contemporaries*, Centre of Contemporary Art, New Delhi.

**1992**

*Heads*, sculptures, Sakshi Gallery, Bombay.

**1993**

Drawings, Sakshi Gallery, Bombay.

**1994**

Still life, Sakshi Gallery, Bombay.

**1996**

Roopankar Contemporary Indian Art – A Collection, Festival of Indian Art, Moscow.

**1997**

*Rediscovering the Roots*, Meseo de la Nacion, Lima, Peru.

**1997**

Ninth Triennale – *India: Seven Artists*, from the Collection of National Gallery of Modern Art, New Delhi.

**1998**

*Living on the Edge*, Art Inc. Gallery, New Delhi.

**1998**

*Face to Face: Artists from Baroda*, Rabindra Bhavan, Lalit Kala Akademi, New Delhi.

**2000**

Joint exhibition with F.N. Souza and Vivan Sundaram at Nature Morte, New Delhi.

**2003**

*Manifestations*, Delhi Art Gallery, World Trade Center, Mumbai and Delhi Art Gallery, New Delhi.

**2004**

*Manifestations II*, Delhi Art Gallery, Jehangir Art Gallery, Mumbai and Delhi Art Gallery, New Delhi.

**2005**

*Manifestations III*, Delhi Art Gallery, Nehru Centre, Mumbai and Lalit Kala Akademi, New Delhi.

## Awards

**1956–61**

Awarded the Government of India Scholarship for Advanced Studies in Painting, under Professor N.S. Bendre.

**1959**

Received the Lalit Kala National Award for Painting, New Delhi.

**1960**

Awarded Gold Medal by Jammu and Kashmir Academy of Art.

**1962**

Received the Lalit Kala National Award for Painting, New Delhi.

**1962**

Received the Bombay Art Society Award, Bombay.

**1967**

Received the French Government Scholarship and studied etching at Atelier 17, Paris.

**1981–82**

Received the Lalit Kala Akademi's Research Grant to work at Garhi Studio, New Delhi.

**1983–85**

Received the Government of India Fellowship to Outstanding Artists.

**1988**

Received the Sahitya Kala Parishad Award, New Delhi.

**1994–96**

Awarded Emeritus Fellowship given to eminent artists in the field of Performing Arts, Literature and Plastic Arts by the Government of India.

**1996**

Received the A.I.F.A.C.S. Award, New Delhi.

**2003**

Honoured by Kalidasa Samman.

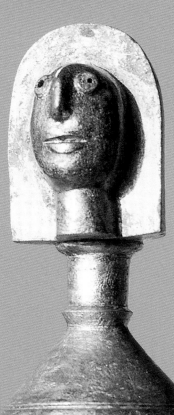

First published in 2007 in India by

Mapin Publishing Pvt. Ltd.
10B Vidyanagar Society Part I
Usmanpura, Ahmedabad 380 014 INDIA
T: 91 79 2754 5390 / 2754 5391 • F: 91 79 2754 5392
E: mapin@mapinpub.com • www.mapinpub.com

Also published in 2007 by

Lund Humphries
Gower House
Croft Road
Aldershot
Hampshire GU11 3HR
United Kingdom

and

Lund Humphries
Suite 420, 101 Cherry Street
Burlington VT 05401-4405
USA

Lund Humphries is part of Ashgate Publishing
www.lundhumphries.com

By arrangement with Grantha Corporation, USA
E: mapinpub@aol.com

Distributed in the Indian subcontinent by
Mapin Publishing Pvt. Ltd.

Distributed in the rest of the world by
Lund Humphries

Text © as listed
Images © Himmat Shah
Photography by Mahattas, New Delhi

ISBN: 978-0-85331-977-1 (Lund Humphries)
ISBN: 978-81-88204-91-5 (Mapin)
ISBN: 978-0-944142-37-0 (Grantha)

British Library Cataloguing-in-Publication Data
A catalogue record for this book is available from
the British Library
Library of Congress Control Number: 2007925894

Designed by Janki Sutaria / Mapin Design Studio
Edited by Diana Romany / Mapin Editorial
Processed by Reproscan
Printed in Singapore

Captions:
*Jacket front*: See page 42.
*Jacket back*: See page 44.
*Page 1*: See pages 76–77.
*Page 2*: See pages 48–49.